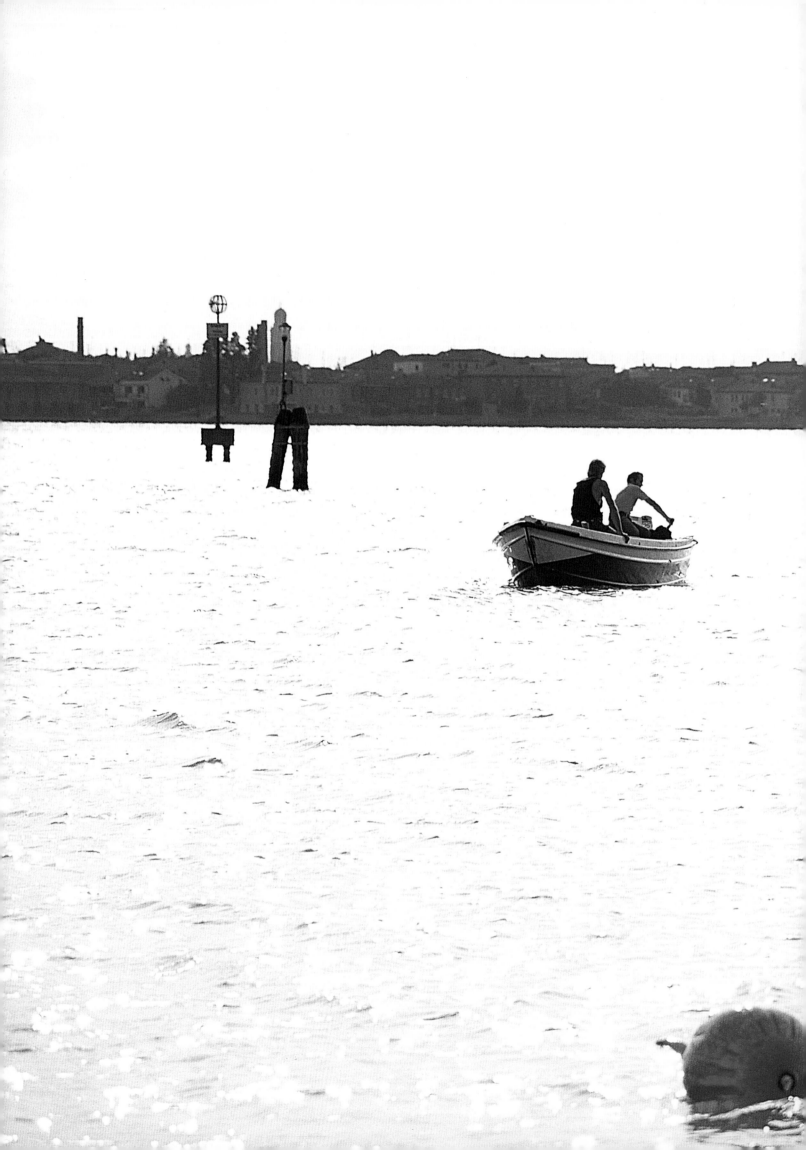

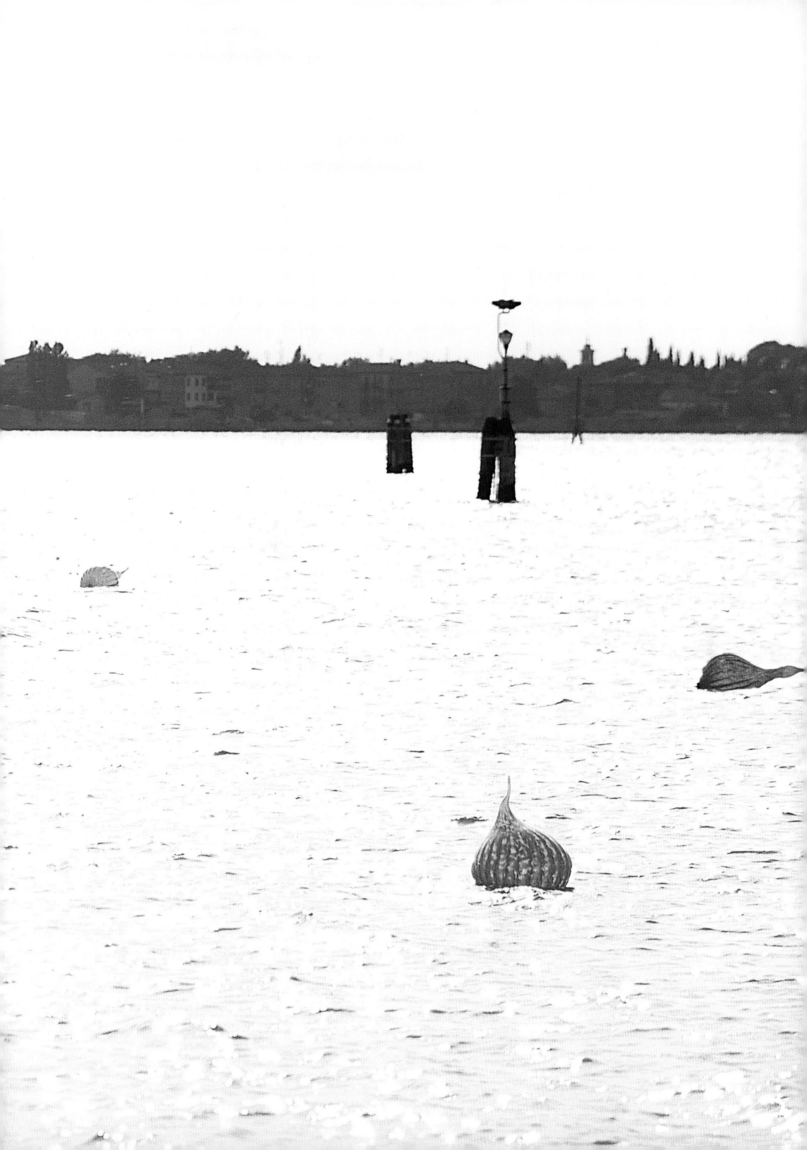

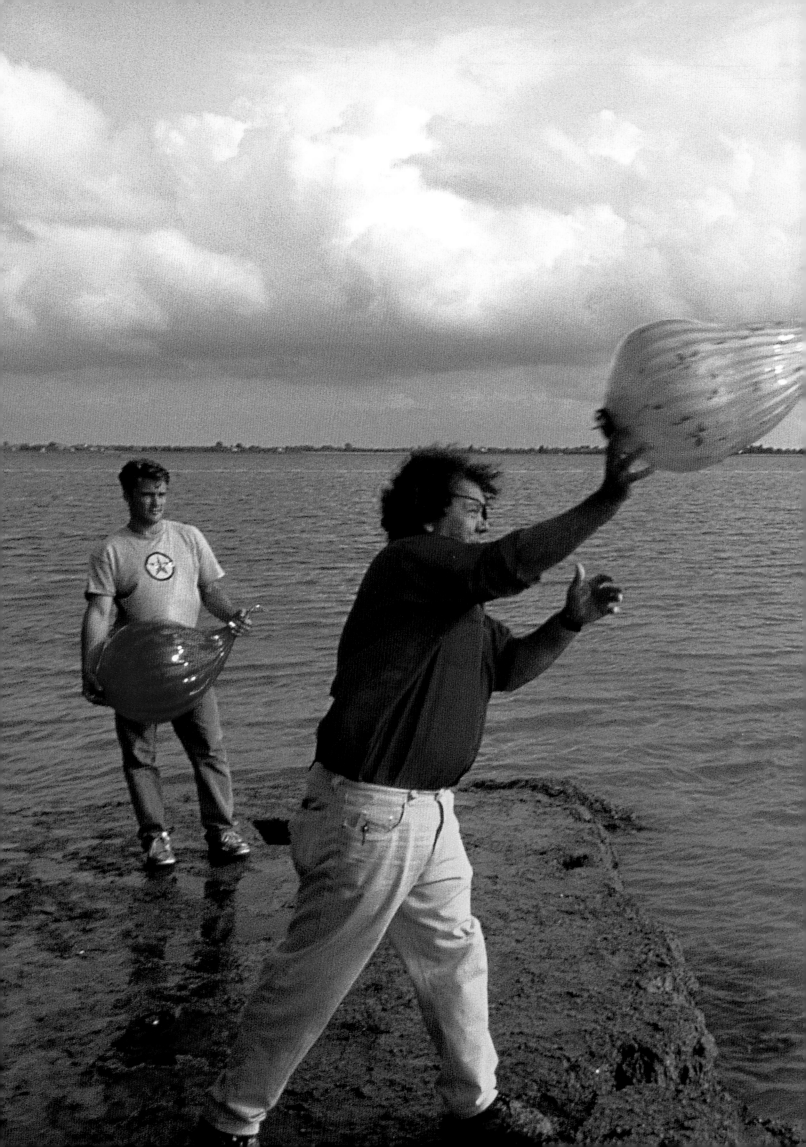

CHIHULY OVER
VENICE

PORTLAND PRESS

The Kemper Museum of Contemporary Art & Design, Kansas City, Missouri, through the support of the following foundations, is sponsoring Chihuly Over Venice and presenting its first U.S. exhibition: UMB Bank, n.a., Peter Brown and Barton J. Cohen, Co-Trustees of the Arvin Gottlieb Charitable Foundation; UMB Bank, n.a., Trustee of the E. Kemper Carter and Anna Curry Carter Community Memorial Trust; UMB Bank, n.a., Trustee of the Geraldine and R.A. Barrows Foundation; and UMB, n.a., Trustee of the Kearney Wornall Foundation.

Second printing of 10,000, 1997.

ISBN 1-57684-005-0

Essays by Dana Self, curator, The Kemper Museum of Contemporary
Art & Design, and William Warmus
Edited by Helen Abbott and Barry Rosen
Designed by Lisa Pettit
Photographs by Russell Johnson, Terry Rishel, and Paolo Della Corte
Printed and bound in Hong Kong

DEDICATION

This catalogue is for the factories and people that allowed us to come into their hotshops and make *Chandeliers*. I will always remain indebted to the Finnish, Irish, Mexican, Italian, and American artists, artisans, shippers, packers, administrators, facilitators, consultants, and engineers who made this project a success—without you Chihuly Over Venice would still be only a dream.

Hackman Nuutajärvi • Finland

Waterford Crystal • Ireland

Vitro Crisa Monterrey • Mexico

Vetreria Signoretto Venice • Italy

The Boathouse Seattle • U.S.A.

I dedicate this book to Ludovico de Santillana, an extraordinary man, who took me into his factory when I was a student and allowed me to work and watch the great masters of Venini, an experience that changed my life.

Dale Chihuly, 1996

CHIHULY IN VENICE
by William Warmus

PROLOGUE

Monday, July 15, 1996

6:30 pm Fiddler's Green. I am penning an entry in the notebook I've begun for Chihuly Over Venice, a writing assignment that will take me from my home near Ithaca, New York, to Venice to observe the construction of some sculptures made of glass and metal. Listening to National Public Radio in the background and distractedly enjoying the whitecaps on Cayuga Lake beyond the window, I hear Terry Gross announce that her guest on Fresh Air tonight is Dale Chihuly. So I start taking notes about her interview, and one incident especially. She asks him, "Why glass?" Dale pauses and responds, "Suppose a child comes upon some beach glass with sun on it. The little kid will drop everything to get that. Maybe I'm that little kid."

Chihuly is that grown up child, a man of impregnable simplicity who inspires complex reactions, an artist always playing with the same basic media: first, and above all else, glass, shaped by the breath of the glassblower, and next, water and light. Breath, water, and light: essentials of life. And now Chihuly was proposing to take his glass to the city of water and light: Venice. A city that engages, indeed overwhelms, all the senses and one where the art of glassmaking has, since the Renaissance, been raised to great heights while veiled in secrecy. And yet an open and curious city, where in the 1960s and 1970s one great man, Ludovico de Santillana, head of the venerable glass house of Venini (with its factory on the island of Murano), opened the doors to visiting American students and artists, Chihuly among the first. So a return to Venice would be a full circle for Chihuly, from the glass on the beach and the student on a Fulbright to the mature artist in the glare of the media.

My notebook starts on May 30, with a few lines about the uncertainty of the dates and sites for the mounting of the sculptures in Venice, a source of tension that would plague Chihuly and his team until late in the summer. I am told that the idea for the entire project started as a plan for a movie, later to

become a television documentary that will appear on PBS, as filmed by KCTS in Seattle, sometime in 1997. A second video crew, headed by Michael Barnard, was soon added to film behind the scenes: a little like *Apocalypse Now* and its documentary-style sister film *Heart of Darkness*.

The idea was to make glass, make it fast and simple, almost as if *for* a movie, at leading factories around the world: in Nuutajärvi, Finland; at Waterford, Ireland, and in Monterrey, Mexico, starting in June 1995. The movie would document the glassblowing process, the interaction of the team of glassblowers from Chihuly's studio in Seattle with the factory-trained glass-makers, the evolution of new artistic processes resulting from this fusion of nationalities and skills (for example, new ways of blowing glass with no reheat-ing), and the final result, beautiful objects in a beautiful city, the individual glass components in all their glittering array filmed as large, assembled sculptures against the backdrop of Venetian canals, palazzi, churches. The movie would portray Chihuly the artist but also record the performance aspect of the entire process: the dance of the glassmaker.

So, Chihuly Over Venice started as a movie, but by early summer of 1996 things were, as big things usually are, spinning out of control. Chihuly had agreed to coordinate the assembly of his sculptures in Venice with the opening of *Venezia Aperto Vetro*, the city's first biennale of contemporary glass, in mid-September. This provided a "seal of approval" and immeasurably energized the biennale, while at the same time it meant that hundreds of leading artists and collectors would become unanticipated "extras" in Chihuly Over Venice, the movie. The stakes were now much higher; the event had to succeed beyond the almost clinical realm of the media. If it weren't there (and by early July there were still no unequivocal site permissions!) or if it didn't look great, the project would fail.

The event had moved to a new level: the unpredictable was intruding. Instead of a media experiment, whose final form could be controlled, it was beginning to resemble James Joyce's novel *Ulysses*, as described by the critic Edmund Wilson:

The world of Ulysses *is animated by a complex inexhaustible life: we revisit it as we do a city. . . . The gross body, the body of humanity, upon which* Ulysses *rests . . . is laboring to throw up some knowledge and beauty by which it may transcend itself.*

Throughout my notebook interviews, like a lawyer trying to trick a witness into contradiction by asking the same question over and over again, I kept asking Dale: "What is Chihuly Over Venice?" Once, he answered: "You know, I never have been able to figure out what it is." While everyone involved knew what they were doing and why during the glassmaking and filming sessions of Chihuly Over Venice, by September few if any of us had a complete idea of why we were doing this in Venice, or what might happen there. The glass world was invited, the team was assembling, the biennale of architecture was opening the same week, the movie had lost the possibility of scripting: all that was left was to hope that the "gross body of humanity" was laboring to make something beautiful.

Friday, August 23, 1996

4:30 pm: I interview Dale for the last time before Venice, reminding him of a day in the early 1980s at his cabin near the Pilchuck Glass School north of Seattle when he, dressed in a woven Indian jacket, posed for Tom Buechner (then president of Steuben Glass), who was painting his portrait, while I finished the last of a 10-hour interview, and as the artist Hank Adams called all over the globe looking for a solar powered typewriter (which he found) for Dale, whose cabin lacked electricity. This story brought a deep laugh, deflecting the train of conversation, and the remark that "as you get older, few things interest you except your work. For breathing space I watch movies. Could movies be the greatest art form of our time?" I say I don't think so. "I maybe agree with you, but I just saw *Trainspotting* for the second time. What about editing? Maybe editing is the most important. Editing: that's the art part, isn't it? But not spending 12 hours a day in a room. You need that vision. You can lose it if you are in the room for hours. Better to go out, make phone calls."

8 pm: I talk to Helen Abbott, the director of Portland Press, at Chihuly Studio. The permissions granted, the installation crew left Tuesday; 8,000 to

12,000 component pieces of glass were shipped to Venice: Chihuly Over Venice is a go! Put another way, Chihuly Over Venice is a non-stop.

VENICE

But I love to feel events overlapping each other, crawling over one another like wet crabs in a basket.

Lawrence Durrell, *Balthazar*

Tuesday, September 3

6:25 pm: Newark Airport, Alitalia gate. Pat Driscoll and I depart for Venice. On the plane I'm reading about the Venetian love of pageantry in *The World of Venice* by Jan Morris.

> *The most memorable of all such galas was arranged for the visit of Henry the III of France, in 1574. . . . As this fleet sailed across the lagoon, glass-blowers on a huge accompanying raft blew objects for the King's amusement, their furnace a gigantic marine monster that belched flame from its jaws and nostrils.*

Wednesday, September 4

Noon: Marco Polo International Airport. Our arrival in the lagoon is by air, but seeking the most memorable effect, we ride a water taxi, a handsome wooden boat with center cabin and space to stand on deck and feel the sea breezes as the waters of the lagoon skim past and serene Venice emerges on the horizon. Because we are staying near the San Samuele stop on the Grand Canal, we enter Venice "the back way" through the narrow Canale della Misericordia and Rio di San Felice, lined with buildings that look, to a New Yorker, like a flooded SoHo. We pass under the Rialto Bridge, emerging from the boat at a wooden pier, surprised to find Chihuly already there: just across the Grand Canal, at Palazzeto Stern, a shining blue *Chandelier*, supported by four steel tubes, as if harpooned and held aloft. And, in front, Michael Barnard with his video camera.

The small-town character of Venice (there are only 12,355 acres of land in the entire Venetian lagoon, including the islands of Murano, Burano,

Torcello, etc.) will prove in the days ahead to be essential to the experience of Chihuly Over Venice, providing all of us an opportunity to visit and revisit the sculptures as if they were in our own backyards, and setting the stage for chance encounters with old friends and colleagues in changing light and spectacular settings. This is brought home when, walking towards St. Mark's Square in the early afternoon, Chihuly (dressed in a rusty pumpkin color shirt and lime green trousers and wearing his famous painted shoes) calls out a greeting as we cross Campo San Moise. He's looking over the sites where the sculptures will be set out and leads us to a little courtyard on the Grand Canal.

2:00 pm: Campiello Remer. The team is finishing the only colorless glass *Chandelier*, made at Waterford in Ireland, most of the components deeply wheel cut by the artisans at the factory. Just after we arrive, Dale is ready to leave again, needs a water taxi; one conveniently arrives in front of the square and discharges an elegant couple, the man smoking a cigar: Anjelica Huston and Robert Graham, in Venice for the film festival. Chihuly has been in an exhibition with Graham, a sculptor, and so they chat while I climb the stone staircase beside the courtyard and admire the view, beside the handsomely decorated apartment whose occupant is enjoying the *Chandelier*, its heavy cut glass facets breaking light beams into rainbow colors like a prism. That same evening we cross over the Rialto Bridge and the Grand Canal to get a look at this sculpture at night, across the water, and discover an orange *Chandelier* at the fish market site. As we stand around it, a couple emerges from the night; she snaps a photograph, and they are gone.

Friday, September 6

Afternoon: Campo della Salute. The square in front of the Baroque Basilica of Santa Maria della Salute, on the Dorsoduro, owns a spectacular view across the busy entrance of the Grand Canal toward St. Mark's Square and is filled at the moment with steel rods, glass spheres the color and shape of pink balloons or transparent melons—and the Seattle team. Parks Anderson, John Landon, Tom Lind, and team raise the steel pyramid of pipes that becomes first scaffolding and then support for the glass. A tiny metal pointer at the end of a plumb line aims straight towards the center of the earth, indicating the

structure is in balance and ready to receive men and glass. Anderson and Landon climb up, a combination of mountaineers and monks, balance and concentration, as they try to ignore the surrounding crowds, media, view and get on with their work. This is the tallest of the sculptures, 21-feet high, its backdrop the enormous church surmounted by *orecchioni*, buttresses for the dome that look like big ears or the spiral decorations on a Venetian vase. As Elena Bernardi on the team says, "Its better to sneak into this city than jump right on top; Venice allows you to be in it but you must be kind. This is a nice piece, it doesn't take away from La Salute: it's here, that's there." Behind me I overhear a collector: "I guess we all must retire to Venice some day."

Venice is the Grand Canyon of cities, its beauty overwhelming, and still the Salute piece will turn out spectacularly well, one of the best, glowing in the sunset while interacting politely with the architecture and statues. Yet by 4:30 pm I hear from Parks Anderson that representatives of a literary event planned for the 14th (8 days away) have just appeared and that Salute will have to come down before then, even though Chihuly was granted a permit. General exasperation. But as the project director, Leslie Jackson, says: "They are concerned with their own media; they have a stage and it would block that. So we put it up, we take it down in a week. We have to take it down anyway." Everyone is too focused on the next site to dwell on the loss of such a beauty, now an ephemeral one, at Salute.

Saturday, September 7
1:15 pm: In front of the medieval cloister of Sant'Apollonia. Dale and the project engineer, Nicola Ferrari, sit on steps leading to the canal behind the Doge's Palace, the Bridge of Sighs to their left, planning the Double Bridge site, the most complicated one, the one the team has reserved for last. Chihuly: "Because the KCTS boat has to go anyway, we can go like this." Ferrari: "I can ask them to stop the traffic on the canal." Chihuly: "Except gondolas. Beautiful gondolas!" as he motions to one that passes a yard away from us on the canal. Later, inside the cloister, the set up proceeds smoothly, Anderson and Chihuly working on the placement of the glass, Chihuly in Neptune pose lofting an intense blue horn shape form for Anderson to grab. The banter of the crew: "Hey Parks—

the cameraman has got the steady cam on. Cool. Can he jog with it?" The bell metal sounds of glass against glass and steel against steel, the English-speaking woman who has brought her friends and says she comes here because it is peaceful, only to find it filled with "Americans!" Later, when I'm alone in the cloister, I understand what she means, the icy blue of the sculpture amplifying the silence of remote places and times, creating a meditative center in the courtyard.

2:30 pm: A tall man with a white beard arrives, starts to give Chihuly a bear hug, spies the camera, says, "No—wait," and changes positions so that the camera angle on Chihuly is better. Jeff Smith, the Frugal Gourmet of PBS fame and a fan of Chihuly's work, is in Venice especially for this event, and as they chat I overhear someone: "That's good—when you get two guys who are good at ad-libbing its always good."

7:50 pm: Fiore, near Campo Santo Stefano. Dinner with Parks Anderson and his family. Anderson arrives late, speaking enthusiastically about a new site they have just selected, on a terrace overlooking the Grand Canal at the Balboni residence, near an extraordinary apartment designed by Carlo Scarpa, Venice's finest architect. He praises the Italian project engineer, Nicola Ferrari, as "our link to Venice: honest, indefatigable, professional."

Chihuly Over Venice is materializing! Anderson: "It's the 'you can do it' factor with Dale. Chihuly gives people permission to do their best." What about bringing American glass to Venice? "Wouldn't it be arrogant to just come here and try to overwhelm Venice? Descend on the city like a rock band? Chihuly Over Venice is like a kiss, a thank you from Dale for the nurturing Venice has given him." I ask Parks what he thinks is going through Dale's mind right now: "You feel the weight—expense—complication—possible embarrassment—you don't want to spend yourself into jeopardy. But the team disperses that fear: tribes work that way. Still, part of leadership is to hold that fear and deal with it alone."

As we speak, team members appear in the open door of the restaurant, stopping by for a moment on their way from the Salute site: "Is Chihuly still at Salute?" "No. He wouldn't stay there by himself." Russell Johnson, the photographer, is elated: " The sunset photos are the best since Finland." The same with the video crew. "We smoked it! Unbelievable. I've never seen glass look like that

at sunset. We shot to the sun—it was like John Landon handing up balls on fire," as he finished assembling the *Chandelier*. Dinner ends with a conversation between us and a transplanted American-in-Venice, a regular patron of Fiore, about the infamous Pink Floyd concert and how it ruined the city. "That's what I say Venice is not—people hanging on the lamps—no respect. You have to respect everything."

Sunday, September 8

11:00 am: In the Campiello Barbaro. A little courtyard near the Guggenheim Foundation, one of the few installation sites where there are trees, and the green mirrored sculpture (composed of gourd shapes blown in Mexico) is going up in the midst of them. I'm aware of motion at a third-floor window above: a young man wearing a pale violet shirt and glasses with heavy black frames is watching us, his movements registered in miniature in each of the mirrored gourds of the sculpture, as if in the multifaceted eye of a giant insect. Chihuly has not yet arrived, and at noon I lunch with Michael Barnard and his friend Jillian Gotlib, a magician and guitarist. Barnard has taped Chihuly at the blowing sessions, so we talk about Finland, where it never really got dark and Dale was highly energized. I hear about a magical last moment there, with the team at a final party and Dale still out on the water with the glass. But then in Ireland Chihuly was down. I think artists try to grab the creative energy they need as it arcs between their moods, but it can't be an easy life.

After lunch, we return to find Chihuly at work, sunglasses over his eye patch. Leslie Jackson tells me that he spent the morning in the tub "rebirthing" himself, and now he's explaining to the camera that the *Chandelier* components are kept round so that rain won't stick to them, that the pod system allows the team to assemble the sculptures anywhere outdoors and provides legs around which parts of the sculpture can "lock" to keep it from twisting in the wind.

5:40 pm: Fondamenta Nuove. Chihuly is taking the team to dinner on the island of Burano, and I meet him at the ferry boat. He has a stack of newspapers, *USA Today* and the *International Herald Tribune*, and we compare same-day front pages between the papers: which headlines are clearer, which stories did each choose to emphasize? It's a pastime, itself an editing process. The

American presidential election is two months away, Dole versus Clinton, and we talk politics, discuss Clinton's cabinet choices. I remember an article in *The New York Times* that drew attention to Chihuly's painted shoes as one of the memorable fashion statements seen among those attending the state dinner for Boris Yeltsin at the White House. His feet cause him pain; to mitigate that and avoid surgery he has shoes made for him, and I suspect he paints them to improve their appearance.

Dale wishes we had Italian newspapers as well, to read about the film festival, and asks: "Who are the great Italian directors? Who are the great writers?" He clearly admires artists who change, citing Picasso: "How can you not change?" Again I question him about Chihuly Over Venice: Is it about art? media? performance? "I don't know what it is but I hope it's original." Passing a semi-deserted island in the lagoon, just a few houses surrounded by overgrown fields: romantic in an isolated way. Dale: "I used to think I wanted to live that way, but not now."

7:30 pm: At the restaurant on Burano. Our group occupies all the outdoor tables. I sit next to John Landon and take notes on a tiny yellow Post-it pad, proving that this form of media is less intrusive than video. "With 800 pounds of steel in the air, you're either energized or intimidated. Parks and I work better in dead silence. My bush experience helped with these structures: Idaho and Alaska, ten years as a logger and on a trap line. A pure world, no lies in the outback, no art of deception. It's where there is a purity to the objects— they create themselves." Landon needs convincing about the integrity of art: the steel pods are meant to have a purity and directness of expression. "I'm much more secure looking down than up, like a bird. In the outback, I was in situations where I couldn't make mistakes—the same with these structures. Even glass should have some risks, even at Salute: putting the last few glass pieces over the top was the kind of risk needed. It's an edgy experience, digging around the glass up in the air on a 2-foot board." As we speak, I hear Tom Hodgson, Russell Johnson's assistant, who has brought his guitar, singing quietly, "Love is kind of crazy with a spooky little girl like you." As the good food arrives, the conversation drifts, and I ask John about his accident: "I took a new Cadillac over a 100-foot cliff. I would do it over again. . .an incredible learning experience. Life

is a delicate thing. It doesn't take much to take it." Later in the week, at the publication party at Louisa Berndt's gallery for Tina Oldknow's book about the 25-year history of the Pilchuck Glass School, I'll turn to page 67 and a dramatic photograph captioned: "John Landon eats dinner off the end of a machete" during Pilchuck's first, primitive year of life. On the opposite page, Toots Zynsky recalls that "Landon built this beautiful tipi. . . . It was magical, it was so beautiful."

Monday, September 9

3:00 pm: At the Double Arch at Campo San Maurizio. Jeff Smith is good at providing a running commentary as we watch the hanging of a dusky pink and purple *Chandelier,* one that looks like it could have been between the arches for a hundred years: "They cause hunger in me. Such beauty. You know you yourself could never create that. This genius with the eye patch and funky shoes: he's eccentric and loves being eccentric. People see an artist like that and realize that he's more human, not less, and the hunger he causes he also satisfies.

"The first time I went to The Boathouse (Chihuly's studio in Seattle) I saw glassblowing and then ate an artistic meal. Art is food for the whole person, and then out comes the cook, Dale. He's a very odd artist. He could never repeat. I think he finds that cheap. Repetitive is when a guy never changes the menu. Chihuly Over Venice is like an enormous dinner party that will never be the same again." Why did he use the word cook? "A cook is someone who is good at the stove." Before we part, Smith names a restaurant for dinner, Alla Madonna: "Not too expensive. Start with crab in the shell. Try the grilled eel or pasta with squid in black ink."

5:45 pm: St. Mark's Square, at the launch of the Hotel Cipriani. I'm on my way to talk to Charles Cowles, the New York gallery owner and one of Chihuly's primary dealers. Events have combined to evoke some lines from Anthony Powell's *A Dance to the Music of Time,* spoken to convince the narrator to attend a literary conference in Venice:

'Take a chance on it. You'll live like a king once you get there.'

'One of those temporary kings in The Golden Bough, *everything at their disposal for a year or a month or a day—then execution? Death in* Venice?'

'Only ritual execution . . . The retribution. . . . takes the form, severe enough in its way, I admit, of having to return to everyday life. Even that . . . you'll do with renewed energy.'

Something to contemplate as I sit in the cabin of the boat and catch the Chihuly at Salute winking in the fluctuating light, a temporary king as well.

Cowles is finishing a swim in the Cipriani's 90 degree saltwater pool, so we sit at a poolside table and I sip a martini and he a Campari and soda. Cowles: "Everybody will be here—his fan club is uniting. *Save Venice* is here and there will be an architecture conference next week. Dale has gained entry into the artworld as an artist. Dale is shooting for the top–as he should. He is a showman, but with guts." The *Chandeliers?* "Technically, the parts are not difficult but the *Chandeliers* are creative and successful. I think the big yellow one in the Barovier Gallery is spectacular." And the steel supports? "Dale has not yet talked god into giving him a skyhook. I don't even look at those. They are like a stretcher for a paint-ing." What do you usually talk to Dale about? "The newest project he's making and how to sell it." Talk turns to how hard it can be to reach Dale, that he moves around too much, overbooks his time. Leaving the table, I spot Dale and Leslie in the pool waiting for Charlie.

Tuesday, September 10

Tension increases visibly: collectors and artists are arriving. Several of the sites pose special problems: at the gondolier works, dust can ruin the freshly paint-ed gondolas, so the team must be limited in size, plus there is concern about the tides damaging the glass and the noise of the glass annoying the neighbors; access to the terrace at the Balboni residence is through an apartment, with the need to respect the owner's generosity and not overwhelm the household with people and media; the Double Bridge site, over water and at one of the busiest pedestrian intersections in Venice, seems almost too evidently difficult. The rush to complete the sites competes with the first rule: avoid accidents. As Anderson indicates, there are three types of failure to guard against: "Aesthetic,

engineering, humiliation." Chihuly is the guardian angel watching over the first, Anderson, Landon, and Lind are in charge of the second; we all hope for the best regarding the third.

Wednesday, September 11

Lunchtime: Near Salute. In such situations, humor helps to soften the edge. Landon and his team have just finished disassembling the beautiful Salute sculpture, and we leave the steel, tools, odds and ends alone as we head for lunch. Landon: "Is someone going to grab something? What kind of tourist would go around saying: This is a hammer from Baghdad?" A hundred pound pipe from Venice? At lunch, the waitress takes over our meal. An Italian speaking member of the team relays her commands: "You don't eat tomatoes with that pasta!" Testing her reaction, I order a crab in its shell and a latte: "No way!"

Thursday, September 12

6:30 pm: At the *Venezia Aperto Vetro* opening, Palazzo Ducale. I think we are amazed that we are all here, at least a thousand packed into the loggia and waiting to enter, spotting friends we haven't seen in years and some we see every day. Nearby me: the artists Jaroslava Brychtova and Stanislav Libensky, Michael Glancy, Dick Marquis, Klaus Moje, Bertil Vallien, Mary Shaffer, Toots Zynsky, Lino Tagliapietra, James Watkins, Richard Meitner, Pike Powers; collectors: the Saxes, the Parkmans, the Andersons, plus the dealers Kate Elliott, Ferd Hampson, Doug Heller; and curators Helmut Ricke and Silva Petrova.

 In the Doge's apartments. Chihuly has placed his sculpture, the *Lampadario del Doge*, directly beneath one of the palace's chandeliers, and it is brilliant. Just as his earlier Venetian series, more Venetian than Venetian glass itself, completes that tradition, so this piece brings the chandelier down to the floor in a perfect act of closure. It also stakes a claim that chandeliers originated on the floor but aspired toward the ceiling. I'm reminded of a discussion I used to have with Clement Greenberg about abstract sculpture and the problem of the finial, a negative term because it took the sculpture into the range of the decorative or ornamental. With Chihuly's *Chandelier*-sculptures, the finial melts into the sculpture, the sculpture and ornament are one. Another way to

write this: Chihuly is making contemporary sculpture that, while advanced from an optical and colorist point of view, is not abstract, not decorative, not realistic. Around 7:10 pm I see George Saxe and George Russell shake hands in front of the *Chandelier*, two Doges of the collector's world.

Saturday September 14

8:45 am: Double Bridge, Ponte Duodo. I hear someone on a cell phone: "Stalemate right now. I don't think the boom can go up that high!" But by 9:40 am the second raising of the 4-legged steel pod looking like a drowned spider over the canal, is a success. I want a camera to capture the intense faces of John and Parks as they strain to bolt each leg to the brackets affixed to masonry walls. "Like Iwo Jima," I hear beside me. Later, I sit with Cliff Hillhouse on the KCTS boat and view the proceedings on his High Definition Television monitor, images direct from the camera mounted high overhead on a moveable boom. Physically, I only need to turn my head to see events transpire under the bridge; electronically, I view them in exquisite detail as if flying above. In the end, it reduces to looking at Chihuly's three-dimensional glass by means of a flat glass surface coated with glowing colors.

3:30 pm: Up on the bridge, I stand next to Chihuly, who motions at all the media: "What good does all this do for making movies, if the acting and writing are bad?" We stand and look up at Dale's technology, glassblowing, which hasn't changed much since ancient Rome. Every moment is being recorded from three or four different angles by the latest camera equipment, cell phones are ringing, and we are plunging into the past. John Landon refers to the pod: "It's a Pyramid." And Marvin Lipofsky, who has joined us, remarks that the steelwork is like the glassblowing benches that Dale designed years ago as a teacher at the Rhode Island School of Design.

4:15 pm: Done! The scaffolding is coming down, I light the Romeo y Julietta cigar Dick Marquis gave me and wait for Jillian to arrive with her tarot cards: I'm using alternative technology to help me write about Chihuly Over Venice.

Monday, September 16

11:00 am: Along Fondamenta San Giovanni dei Battuti. At Pino Signoretto's glass studio on the island of Murano. Perhaps because Pat and I leave Tuesday morning, whenever I see members of the "cast" from the last week assisting or passing through to observe the glassblowing, it's like watching curtain calls at the end of a performance: Ann Richards, former governor of Texas; the Parkmans with their cameras; George Saxe to one side in serious conversation with Lino Tagliapietra; George Stroemple, a leading collector of Chihuly's work; and the members of the team. During a break in the blowing, Dale sees me with the *Herald Tribune*, asks: "Did we compare newspapers today?"

Chihuly is at the center of this space, in this dark equipment-jammed industrial setting, working with Pino Signoretto and Lino Tagliapietra, evolving a new design for a *Chandelier*, swelling ocean forms, glowing hot, covered with sea creatures. I overhear Ann Richards explaining that the one they are now shaping will become a turtle.

12:15 pm: I join Leslie Jackson for lunch and an "exit" interview. We sit in the nearly empty indoor dining room while the crew and a few friends eat outside, and I wonder how Dale is holding up, constantly mobbed by people and deluged with details. "Most artists are more prickly, but Dale enjoys people. Still, Dale needs space and I have to take it for him, I'm his only space-taker." We talk about his need to balance the social with the making of art: "The soul of what Dale does is in the glassblowing; he is at his best on the floor of the blowing room. For this blow we asked visitors not to talk to him, to allow him space, to be aware that they have been invited into an extraordinary space. We need to nourish that, to schedule it into his calendar: the way he is around the fire, a special focus, a different state of mind." As if he has overheard us, Chihuly looks in, wants to know if we would like to talk with the project engineer from Finland, while at the same time I read in his face the need for some space and for someone to take it for him.

7:00 pm: Palazzetto Pisani. Throughout a week of gorgeous, 70 degree weather, the city glowing under blue skies and dramatic clouds, there have been delightful parties in honor of Chihuly Over Venice, given by George and Dorothy Saxe, Doug and Dale Anderson, and tonight, a dinner party for

friends of the International Museum of Modern Glass, hosted by George and Jane Russell in a seventeenth-century palace with a nearly intact interior. After dinner, Russell congratulates Leslie Jackson: "I'm in the stock market and can say that when Leslie joined the volatility came way down" and speculates, "This is probably the greatest event in modern glass, so let's toast—to Dale."

EPILOGUE

To recapture the past is possible then. But if one truly wants to recapture it, one has to run down a kind of corridor that every instant becomes longer and longer. Down there at the end of the remote, sunny point where the corridor's black walls converge, there stands life as vivid and throbbing as once before when it was first experienced. Eternal then? Eternal, of course. But nonetheless farther away, more and more elusive, more and more unwilling to permit itself to be possessed.

Giorgio Bassani, *The Romance of Ferrara*, Douglas Radcliff-Umstead, trans.

Sunday, October 27

5:00 pm: Ithaca. So what was Chihuly Over Venice? For me, as a writer, it is a work in progress as I conduct more interviews and type out notebook excerpts. For some, it was about selling, or owning, or seeing: with one eye or an electronic lens; as a gourmet, or a cook, or a curator; in Venice on a nostalgic visit, a working trip, taken by surprise. We all lived like temporary kings, a gift from the artist, and watched as the sculptures grew and took their place in the ensemble of buildings, people, water, and light of the city. After a time they became landmarks: "Meet you at the Double Arch and we'll walk to dinner." It is frustrating that I spent two weeks in Venice, have nearly two hundred pages of notebook entries, and nonetheless my record is silent about significant details: talking to the gallery owner Kate Elliott, Dale's longtime friend, on October 4, she reminds me that the *Chandeliers* were best at night (when chandeliers are meant to dominate a room), a fact I enjoyed but never wrote about in Venice! There is something about Chihuly that makes you experience everything, all at once, and as you are overwhelmed you know that there are still

secrets, back there, in the furnace room, with the glassblowers, where he is at work to catch every scrap of inspiration. That day at the Double Bridge, when Chihuly dismissed all the technology with a few words, it made me think that Chihuly Over Venice, as much as anything, was about traveling back in time, down that dark corridor to whatever is best in the past and worth propelling into the future. That's a trip you don't take with the media, its one you make with your heart.

William Warmus is a writer. While at The Corning Museum of Glass he curated *New Glass*, and later edited *Glass* magazine. His exhibition *The Venetians: Modern Glass* was described by *Il Giornale D'Arte* as "The most important exhibition of Italian glass ever organized in the United States" and *The New Yorker* noted that "The American Dale Chihuly's [pieces in the show] are the wildest by far."

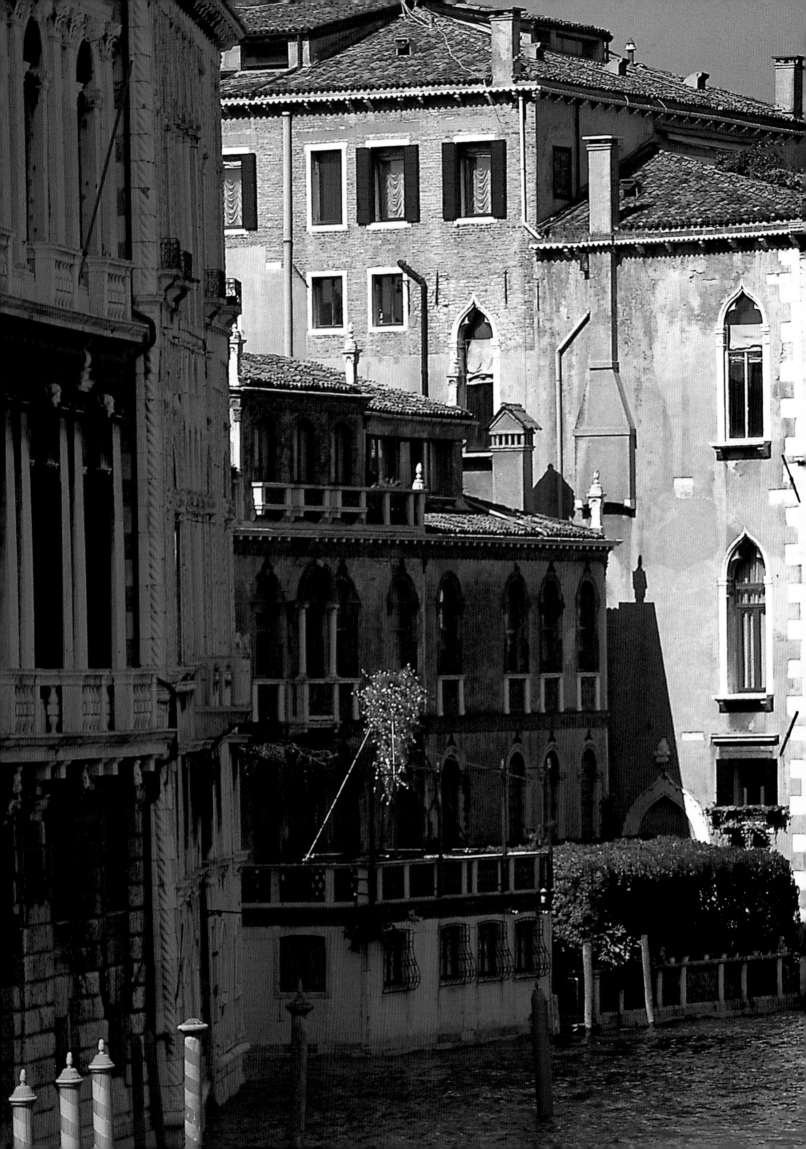

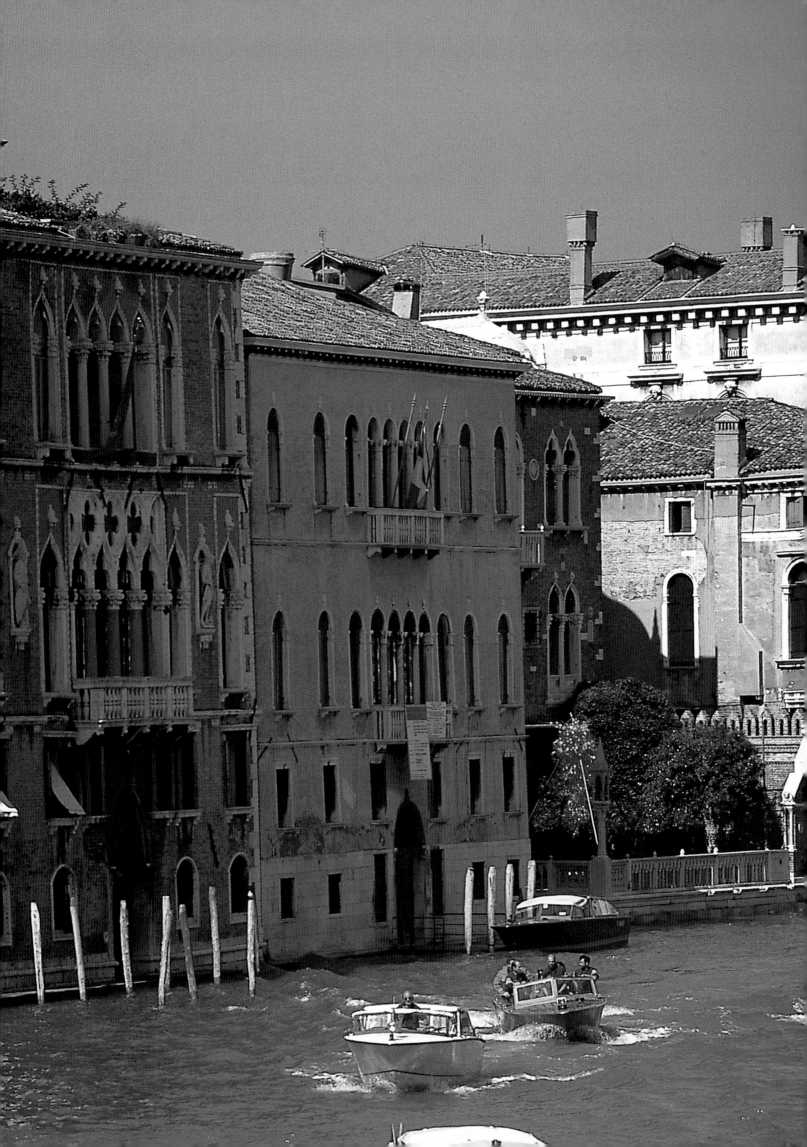

THE SPECTACLE OF BEAUTY

by Dana Self

Beauty connotes pleasure, and Dale Chihuly's glass resonates in the arenas of public pleasure and private desire. Gazing at the beautiful in art with unrestrained longing allows us visual and sensual pleasures that we have conditioned ourselves to live without or, at least, live with in fugitive guilt. For in the visual arts, beauty has come to represent the commodification of luxury goods and capitalist gain. However, Dale Chihuly's explorations of the unique, various, and unpredictable possibilities of glass, its history and relationship to our bodies allows us not only to experience pleasure but also to derive a meaningful experience from beauty.

According to many contemporary theoreticians and art historians, one aspect of beauty's long and complicated history is its emersion from the body, or our ideas about the body—from the Greek idea of man as the measure of all things, to the male gaze directed at the body of woman, which has been loaded with ideas about what constitutes beauty, decency, and/or normalcy. Thus beauty has become burdened with the weight of religious, gender, sexual, cultural, and social politics, making its appreciation a tricky endeavor. According to Dave Hickey in *The Invisible Dragon: Four Essays on Beauty,* "The history of beauty, like all history, tells the winner's tale; and that tale is told in the great mausoleums where images like Caravaggio's, having done their work in the world, are entombed—and where, even hanging in state, they provide us with a ravishing and poignant visual experience."[1] Hickey questions whether contemporary images are enhanced by their institutionalization, or whether they might do better "out" in the world. Chihuly has, in his way, answered that question. He has taken his works out of the institution—without abandoning it or its ideologies—into the public arena of corporate hallways, restaurants, Fifth Avenue capitalism (Liz Claiborne), rivers, bridges, deserts, and almost anywhere else imaginable. Emerging from the hermetically sealed space of the institution to find life in the world at large, Chihuly's glass changes the dynamics of what, these days, constitutes art and beauty—the ostensibly intellectual and the popular—for Chihuly is about aesthetics as much as commodification.

Therefore, one of the questions raised by Chihuly's work is whether it merely asserts the status quo of beauty, in its most shallow and ill-perceived sense, or whether it, in its utter provocativeness, laden with commodification, a certain Hollywoodism, and sheer pleasure transgresses the status quo because it proclaims its beauty in no uncertain terms.

Chihuly's glass pieces, including and even especially the *Chandeliers*, have become objects of wonder and enchantment from which we derive visual pleasure, and visual pleasure has historical precedence. As the art historian Svetlana Alpers notes, the encyclopedic collections of Renaissance princes often centered on objects that "tested the border between the craft of nature and that of culture, natural artifice and man's—goblets fashioned out of shell, for example, or worked coral."[2] Chihuly's art straddles the divide, for his glass appears highly artificial yet simultaneously natural. Chihuly's titles such as *Seaforms* suggest the natural world and conjure visions of splendid urchins and other fantastic ocean creatures, as the *Persians* (the *Brooklyn Wall* installation at the Brooklyn Museum) connote flight and fantasy. His work challenges the notion that perfection is embodied only in natural forms, for his slickly perfect, but wildly excessive glass objects feel as though they inhabit the interstice between artifice and nature. And, in experiencing beauty and pleasure, what we *feel* motivates our response. According to Alpers, "The visual interest accorded a flower or a shell in nature is challenged by the visual interest of the artist's representational craft."[3] This visual interest, or more specifically, artists' and collectors' fascination with the world made visible, continued from Renaissance princes' collections through the eighteenth-century natural-history cabinet.

The pleasure of looking, from which Chihuly's work emerges full-blown, has historically been immersed in the spectacle of vision and wonder. Eighteenth-century cabinets of curiosities contained paintings, bronzes, books, animals, plants, and other objects for both public and private contemplation. Barbara Maria Stafford in *Good Looking: Essays on the Virtue of Images*, writes, "The natural history cabinet as the museum for an epitomized creation of spectacle incarnate was, I believe, the source for this spectacularization of experience. Moreover, the conflicts over its nature and function and the tensions between a supposedly serious linguistic system or ordering and the merely

appealing exposition of images, has a distinctly contemporary ring."[4] It was that visual spectacle and the idea that beauty should be ghettoized to the realm of, in Stafford's words, the "merely appealing" that established a continuing and problematic fascination with not only the beautiful but also the exotic. Chihuly's glass trades on exoticism. The obsessive and excessive ornamentation feels exotic and may be compared to historical (Victorian) ideas of "orientalized" or non-Western cultures. Even his titles, such as *Persians* and *Venetians*, have roots in Victorian England and France. For instance, during the Industrial Revolution, British and French glassmakers were inspired by the patterns of both Islam and Venice— exotic "Others" to these imperialist nations.

While Chihuly's *Chandeliers* and other forms may look like splendid imperialist booty, they resonate in other ways. The production of glass as art object is not a solitary artistic endeavor undertaken in a pristine studio setting. It is produced in a hot, sweaty, even dangerous industrial environment. Ironically, then, the resonance—intimations of a larger social group or community—of the industrial factory and its workers emerges from the aura surrounding Chihuly's glass. The Chihuly Over Venice *Chandelier* project is a particularly potent example of the factory's working ethos. Chihuly traveled to Finland, Ireland, and Mexico to blow glass in local factories. And yet, the commercial factory is not the studio of the artist; it is the production site of generations of workers. By inserting the artist into the locus of commodity production to create fine art rather than goods, the spectacular object, which dances between art and industry, emerges. According to Guy Debord, "In the spectacle, one part of the world *represents itself* before the world and is superior to it."[5] Chihuly's *Chandeliers* refer to parts of the world—industry and utilitarian glass goods. However, through his artistry, Chihuly converts potential goods—goblets, bowls, vases—to beautiful art objects that represent an aura of both industry and utility without being either industrial or utilitarian. Within that aura, Chihuly produces what Debord refers to as the spectacle.

In the Waterford, Ireland, factory the spectacle is the most provocative. Here, where for generations leaded crystal has been made for the tables of those who could afford it, Chihuly and his team worked, combining art and industry. Chihuly's merging of art and industry has historical precedence in

perhaps the most celebrated combination of the two: Joseph Paxton's Crystal Palace, a work of art itself, which comprised more than a million square feet of glass, and the event for which it was built, the 1851 Great Exhibition, or Exhibition of the Industry of All Nations. In this exhibition, cut crystal (from Britain) was noted as the height of the glassmaker's art, which may be attributed to both quality and nationalism. The immersion of the Chihuly production team into the industrial factory not only changed the nature of the factory for a short time, it also affected some of the glass workers. According to a Chihuly staff member, Joanna Sikes, "The factory etchers were very excited and applauded Dale because in all the history of Waterford, they were never allowed to etch a curved line. And of course, that's what he had them do."[6] The spectacle of a changing environment and of a changing vision then affects the spectator and the worker as well. The presence of television crews, photographers, biographers, etc., into the factory changes its meaning, its order, and its structure, at least temporarily. Chihuly's creation of beautiful and often unpredictable art objects in the commercial factory environment, where the same objects have been made for decades, may startle and delight us as it may have the Waterford employees with whom he worked. As scholar Ruth Lorand writes, "Beauty tends to surprise us by offering a new unpredictable order."[7]

Our pleasure in beauty, defined partly in the curved lines the Waterford etchers produced for the first time, and capitalized on in our view of the finished work of art, leads us to the exaltation of the beautiful object and even the fetish. The fetish may be read from a variety of theoretical positions, including anthropological, first identified in the cult objects of West Africa; Marxist, the commodity; and Freudian, the substitute for desire after trauma; all three of which "define the fetish as an object endowed with a special force or independent life."[8] Contemporary scholars have broadened the term as a useful vehicle with which to investigate cultural signifiers, including clothing, beautiful objects, architecture, and ornamentation. Chihuly's *Chandeliers* and other glass objects with their obsessive ornamentation, for all practical purposes, subsume structure and surface around them so that nothing may disturb the viewer from aesthetic pleasure. The pieces have no function in its strictest definition—ritual or ordinary—other than beauty. The charismatic effect, then, is to heighten desire

(looking) and produce a fetish. According to Mark Wigley, "The word fetish carries the senses of 'fabrication,' 'making,' 'artifice,' 'cosmetics,' 'makeup,' 'adornment,' and 'embellishment.' This chain carries both the sense of the ornamentation and structure. . . . The fetish, by definition, convolutes the distinction between structure and ornament."[9] Because Chihuly produces his works in such a way that they are often constructed as entire installations, the sense of sheer ornamentation becomes almost overwhelming, forming a site where ornament and structure collapse together. According to Massimo Carboni in his article "Infinite Ornament," "A fundamental property of ornament, in fact, is that it is offered as a form of waste, luxury, excess, expenditure without compensation."[10] Thus, the overwhelming beauty of the glass produces the fetish with an independent life of its own. The English literary theoretician Stephen Greenblatt offers a theory that may be useful in our understanding of how we appreciate the intensity of our love of and desire for beautiful objects. He writes:

> *This understanding . . . is centered on a certain kind of looking, the origin of which lies in the cult of the marvelous and hence in the artwork's capacity to generate in the spectator surprise, delight, admiration, and the intimations of genius. The knowledge that derives from this kind of looking may not be very useful in the attempt to understand another culture, but it is vitally important in the attempt to understand our own. For it is one of the distinctive achievements of our culture to have fashioned this type of gaze, and one of the most intense pleasures that it has to offer.*[11]

Desire is the driving force behind the gaze and the pleasure of looking. How do Chihuly's *Chandeliers* and other glass forms mediate and transmit our experience of desire? Much of Chihuly's work is large—sized to the human body and beyond; therefore we may relate to the works on a corporeal as well as aesthetic level. The biomorphically shaped *Baskets* often cradle other, smaller *Baskets*, while the *Chandeliers* can be monumental, sized to overpower and command the space in which they are installed. Chihuly's glass has cavities and protrusions, as do our own bodies. Consuming and subsuming are part of our physical relationship with one another and with the world around us. Because we may experience Chihuly's works in such a physical manner—they intrude

into our space, they are slick and sexy, slightly dangerous, making us want to touch them—the distance between the glass and us is narrowed by the reciprocity between our bodies and the work, which is both surprising and disturbing. Not only is working with molten glass dangerous, but even our appreciation of the final art object is tempered by the dangerous nature of glass. While sensually beautiful, any glass can break or shatter. Therefore, the unexpected tension that Chihuly creates between attraction and danger may heighten our sensory experience of the work.

Chihuly's work seems to be unpredictable in that the forms rarely add up to the expectations we may have of them. For instance, he titles many of the bowl shapes *Baskets*, yet they are made neither of fiber nor reed, nor do they function as a utilitarian object. Additionally, the *Chandeliers* are not lamps, nor are they intended to function as such. By subverting the causal assumptions we make in language based on our experience, Chihuly creates a new order based on his own personal vision, thus surprising us. Surprise may contribute to the desire that is inherent in our gaze, for the unexpected often adds to our experience of pleasure. The mystery of glass compounds the experience because glass is the only traditional medium that cannot be touched by the naked human hand while it is being formed. Looking becomes, then, one of the key components in the making of glass, as well as in the appreciation of it after it is complete. And in that pleasurable looking filled with desire and longing, we also find enchantment. Greenblatt writes, "Looking may be called enchanted when the act of attention draws a circle around itself from which everything but the object is excluded, when intensity of regard blocks out all circumambient images, stills all murmuring voices."[12] History amplifies our shifting gaze and our bodily and intellectual responses to beauty. Chihuly's fantastical explorations into industry, art, capitalism, commercialism, history, pleasure, and finally and always, the beautiful demonstrate that beauty does produce a meaningful experience of the world. Beauty, far from a guilty pleasure, allows us to examine the re-creation of meaning through a path of pleasure and the wonder of looking.

Dana Self is Curator of The Kemper Museum of Contemporary Art & Design. The content of this essay has been shaped in part by readings of Dave Hickey's work, including, but not limited to, *The Invisible Dragon: Four Essays on Beauty*, 1993.

NOTES

1. Dave Hickey, *The Invisible Dragon: Four Essays on Beauty* (Los Angeles, CA: Art issues.Press, 1993) p. 20 .

2. Svetlana Alpers, "The Museum as a Way of Seeing," 25-32 in *Exhibiting Cultures: The Poetics and Politics of Museum Display*, editors Ivan Karp and Steven D. Levine (Washington, D.C.: Smithsonian Institution Press, 1991) p. 26.

3. Alpers, p. 26.

4. Barbara Maria Stafford, *Good Looking: Essays on the Virtues of Images* (Cambridge, MA: The MIT Press, 1996) p. 192.

5. Guy Debord, *The Society of the Spectacle* (Detroit, MI: Black and Red, 1970) p. 29, in Susan Stewart, *On Longing: Narratives of the Miniature, the Gigantic, the Souvenir, the Collection* (Durham, NC: Duke University Press, 1993) p. 84.

6. Shawn Waggoner, "Chihuly Over Venice," 38-43, *Glass Art*, May/June, 1996, Volume 11, Number 4, p. 40.

7. Ruth Lorand, "Beauty and Its Opposites," 399-405, *The Journal of Aesthetics and Art Criticism*, 52:4, Fall, 1994, p. 403.

8. Hal Foster, "The Art of Fetishism," 6-19 in *Fetish, The Princeton Architectural Journal*, Volume 4, editors Sarah Whiting, Edward Mitchell, Greg Lynn (New York, NY: Princeton Architectural Press, 1992) p. 6.

9. Mark Wigley, "Theoretical Slippage," 88-129, in *Fetish, The Princeton Architectural Journal*, Volume 4, editors Sarah Whiting, Edward Mitchell, Greg Lynn (New York, NY: Princeton Architectural Press, 1992) p. 101.

10. Massimo Carboni, "Infinite Ornament," 106-111, *Artforum*, September 1991 p. 110.

11. Stephen Greenblatt, "Resonance and Wonder," 42-56, in *Exhibiting Cultures: The Poetics and Politics of Museum Display*, editors, Ivan Karp and Steven D. Levine (Washington, D.C.: Smithsonian Institution Press, 1991) p. 53.

12. Greenblatt, p. 49.

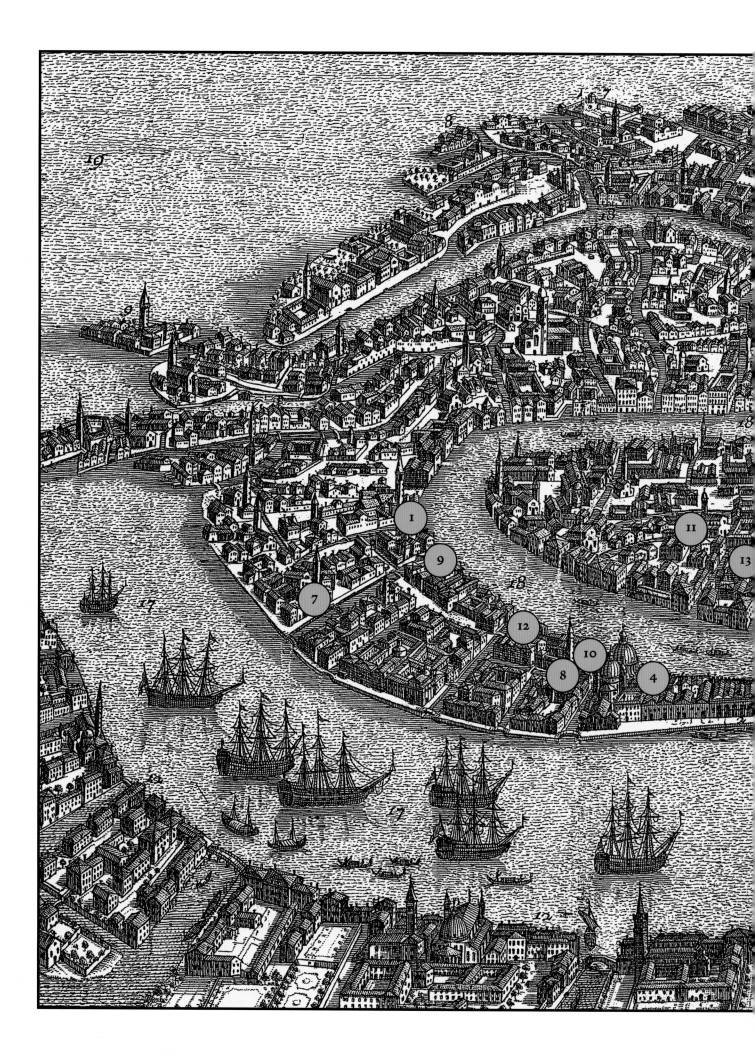

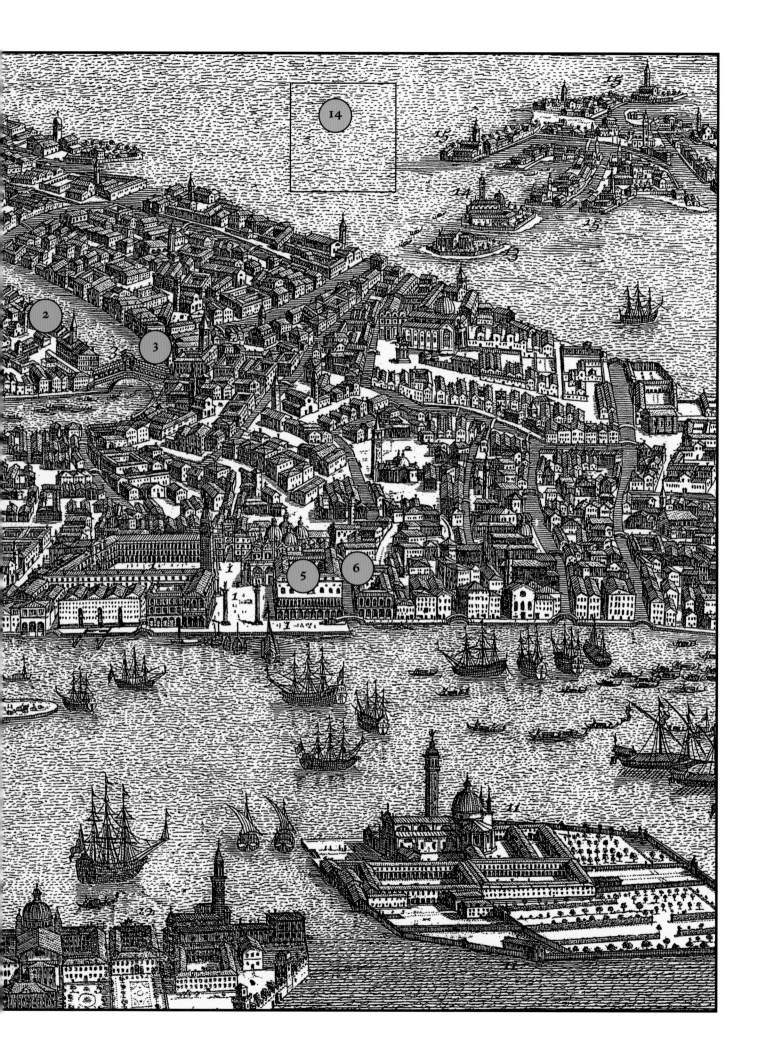

PALAZZETTO STERN

Ireland

313 pcs / 1565 lbs

12′ 6″ h x 5′ 11″ w

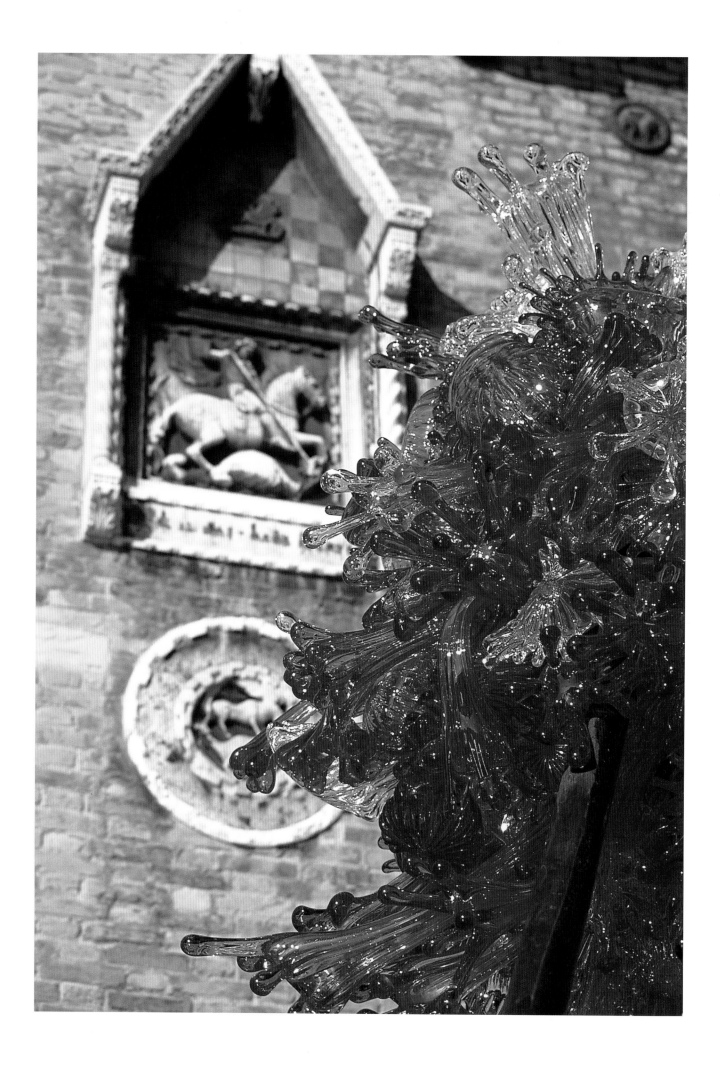

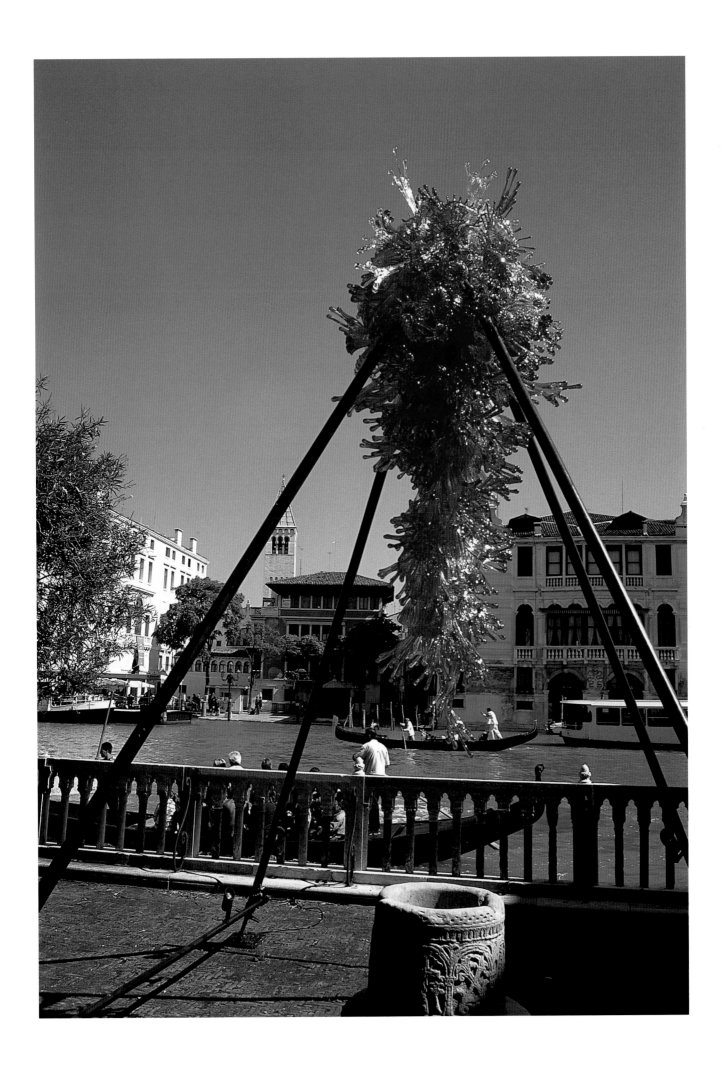

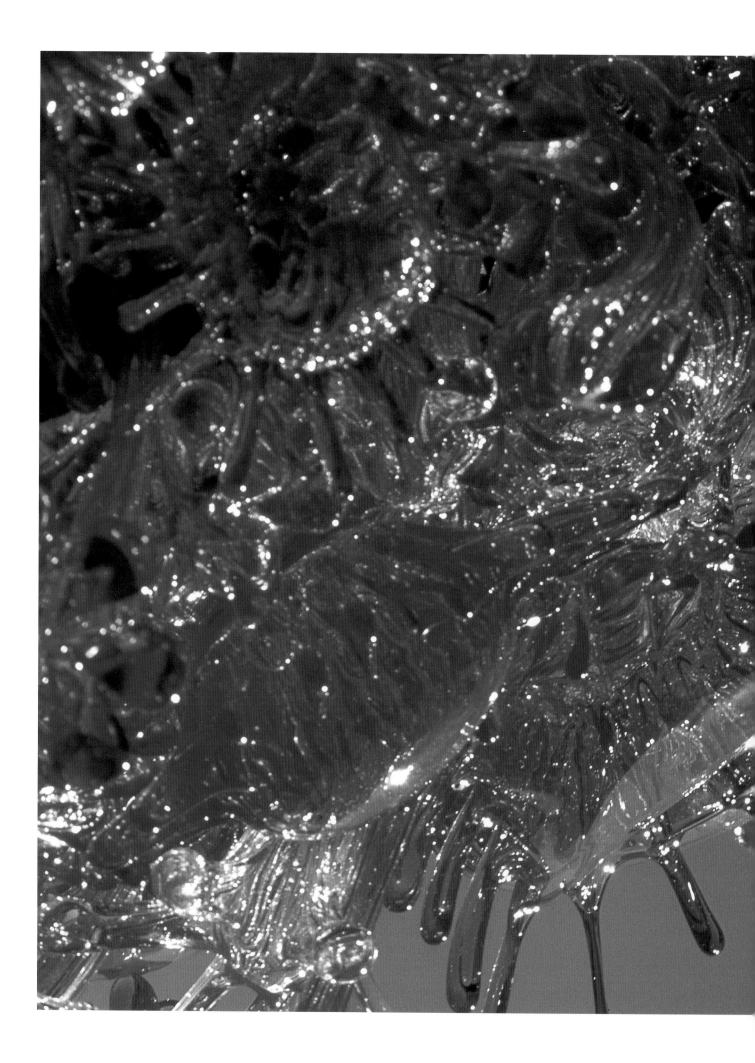

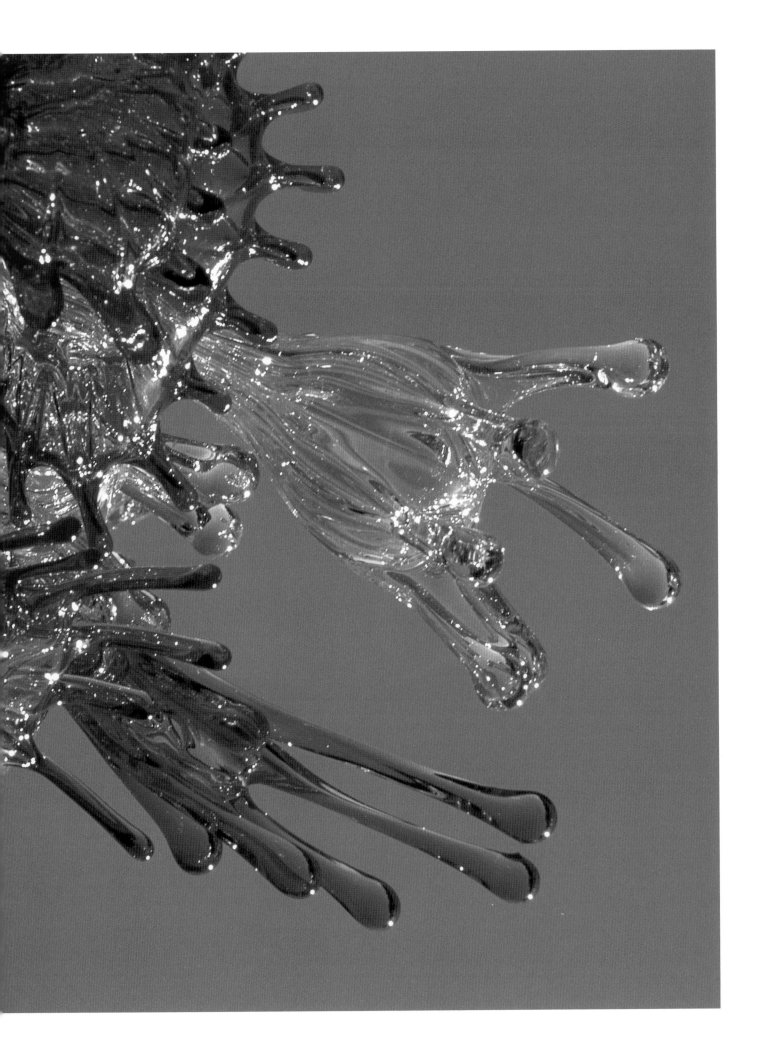

MERCATO DEL PESCE DI RIALTO

United States

111 pcs / 986 lbs

8´ h x 5´ w

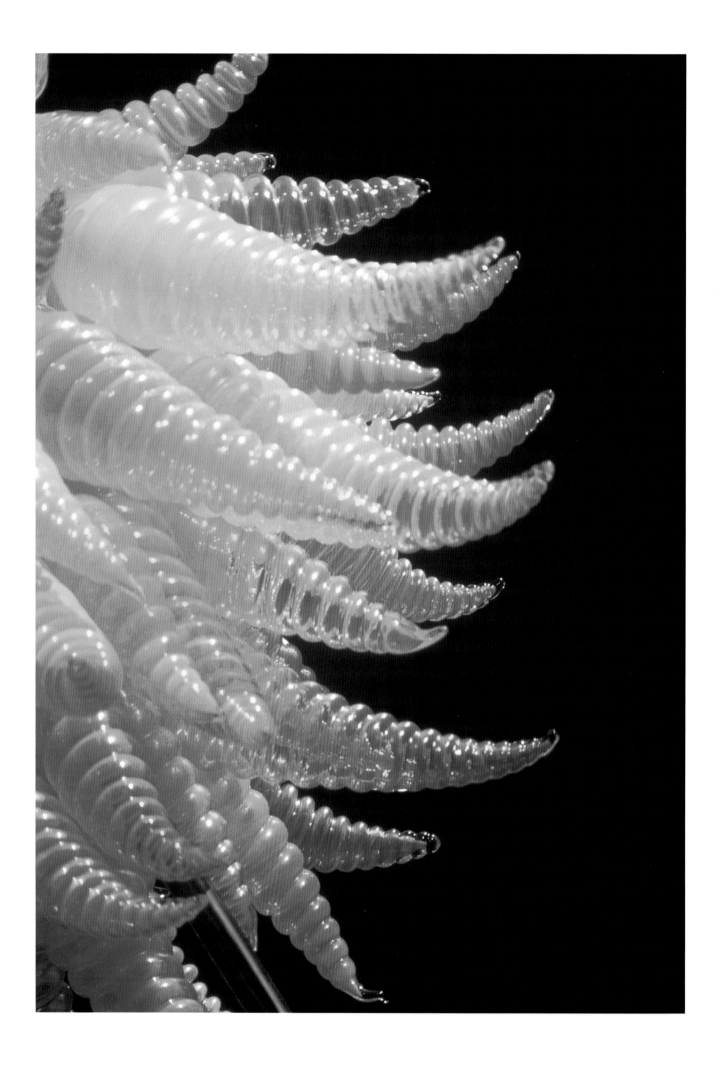

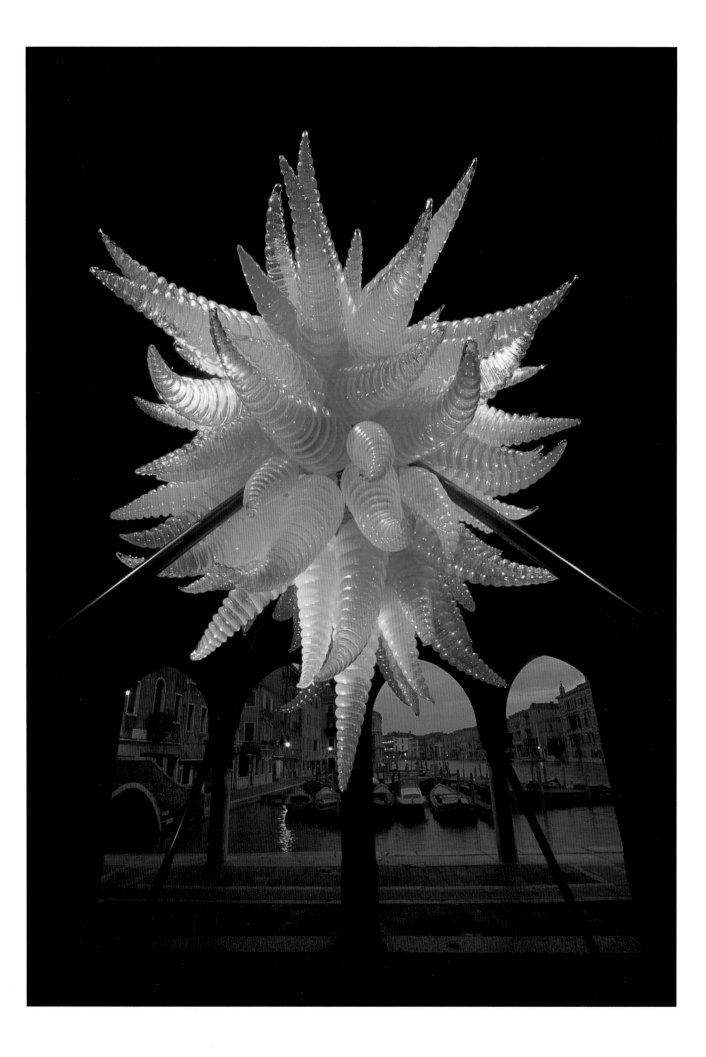

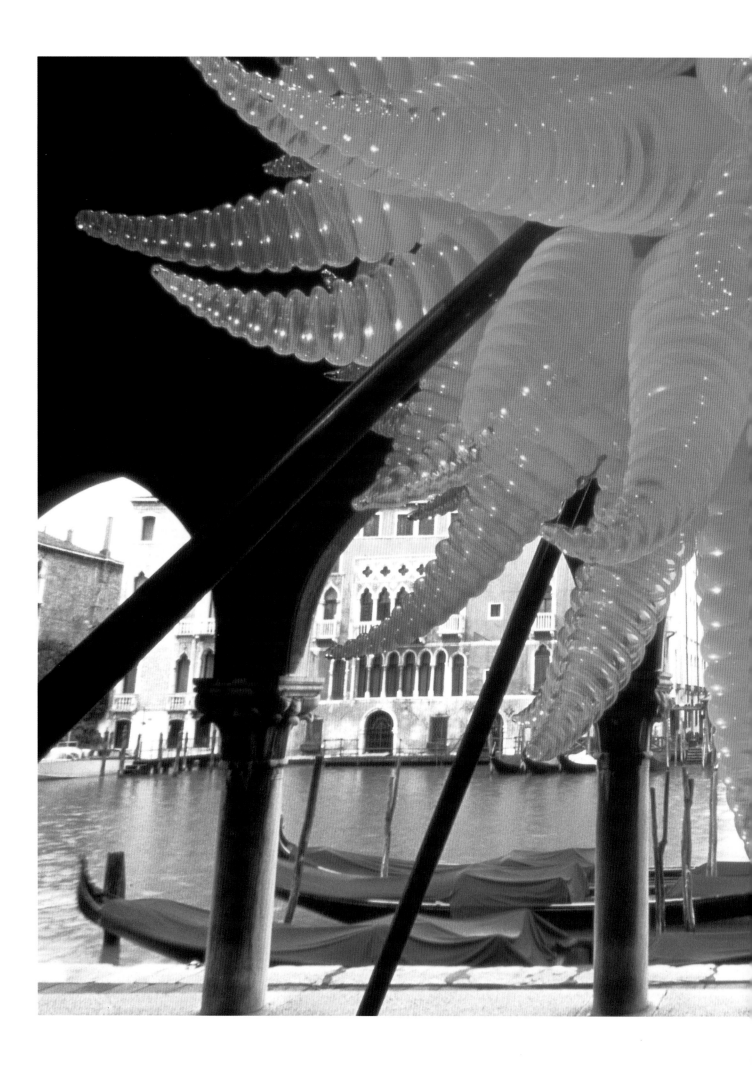

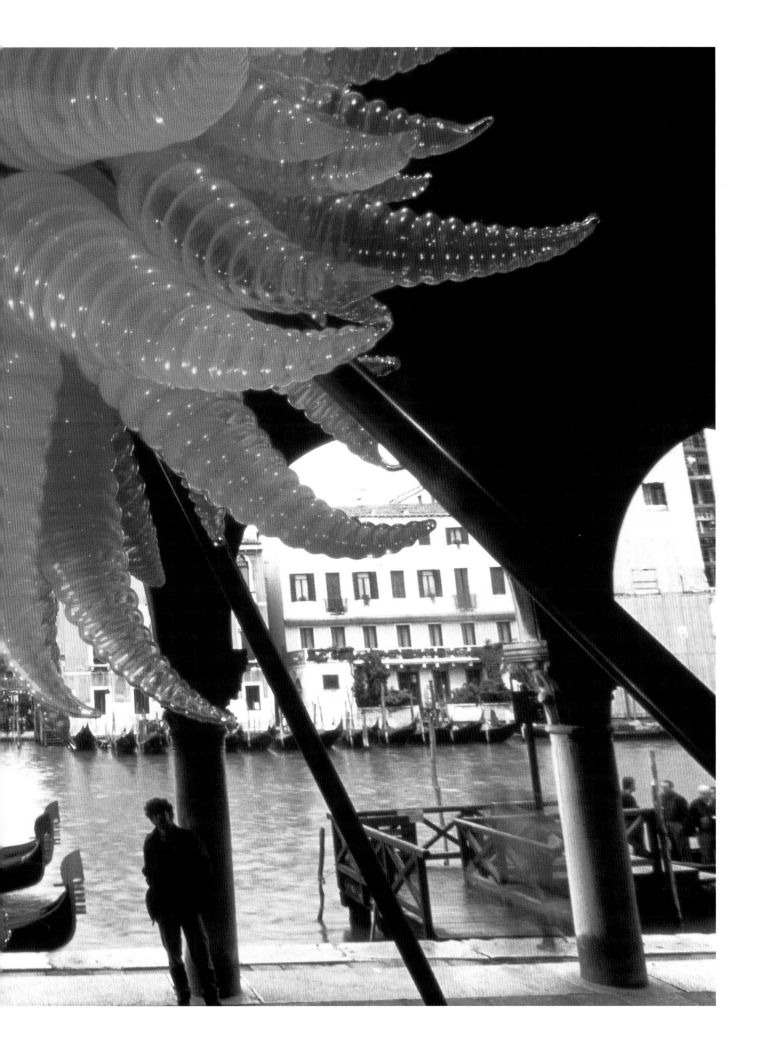

CAMPIELLO REMER

Ireland

285 pcs / 1811 lbs

12´ 6˝ h x 5´ 5˝ w

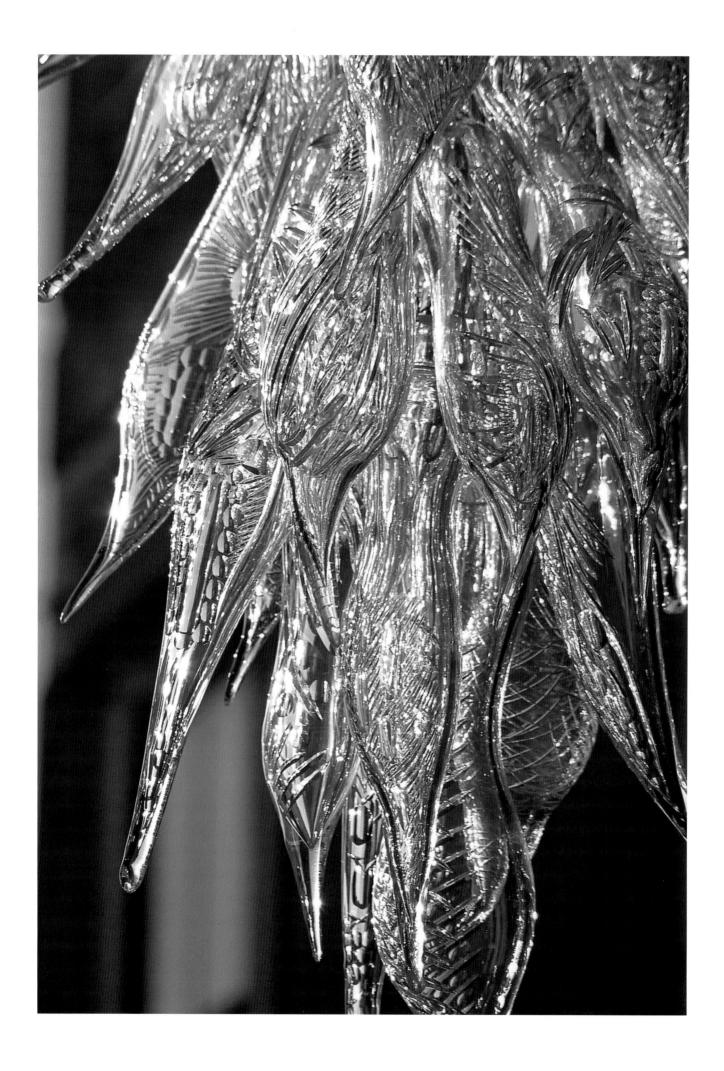

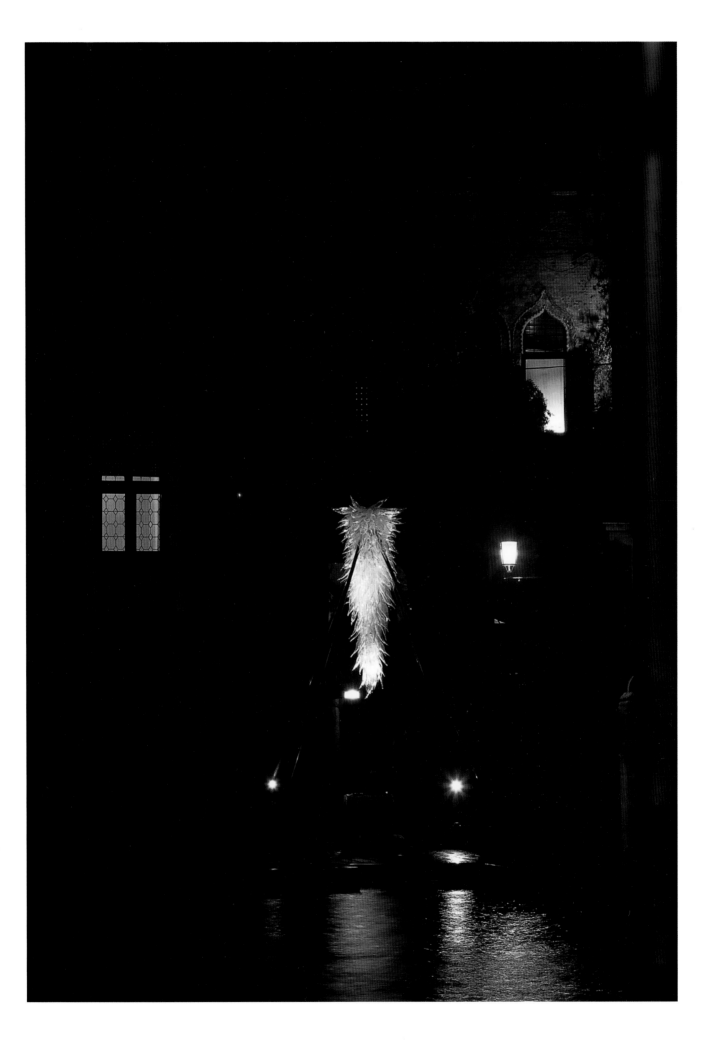

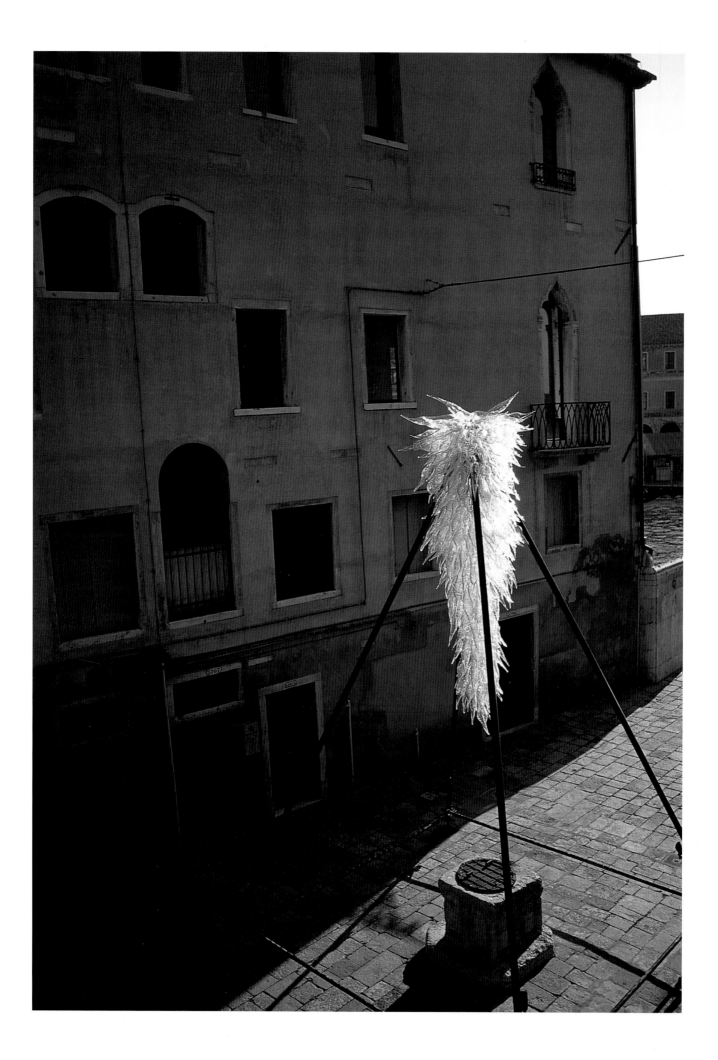

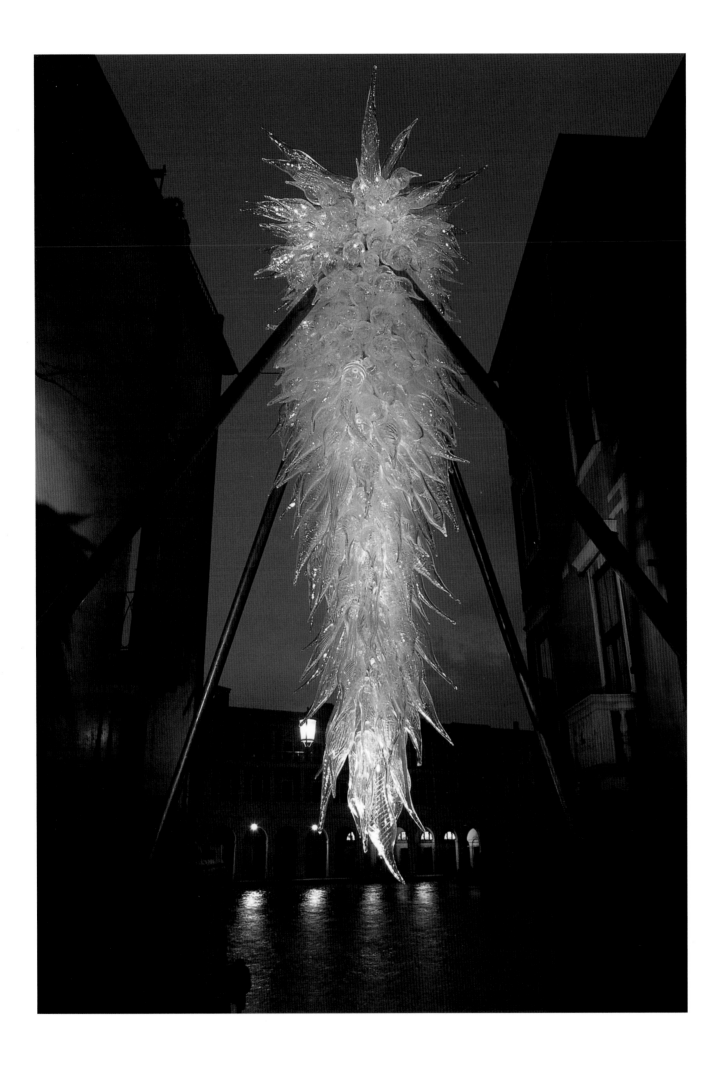

CAMPO DELLA SALUTE

United States
131 pcs / 1500 lbs
14´ h x 6´ w

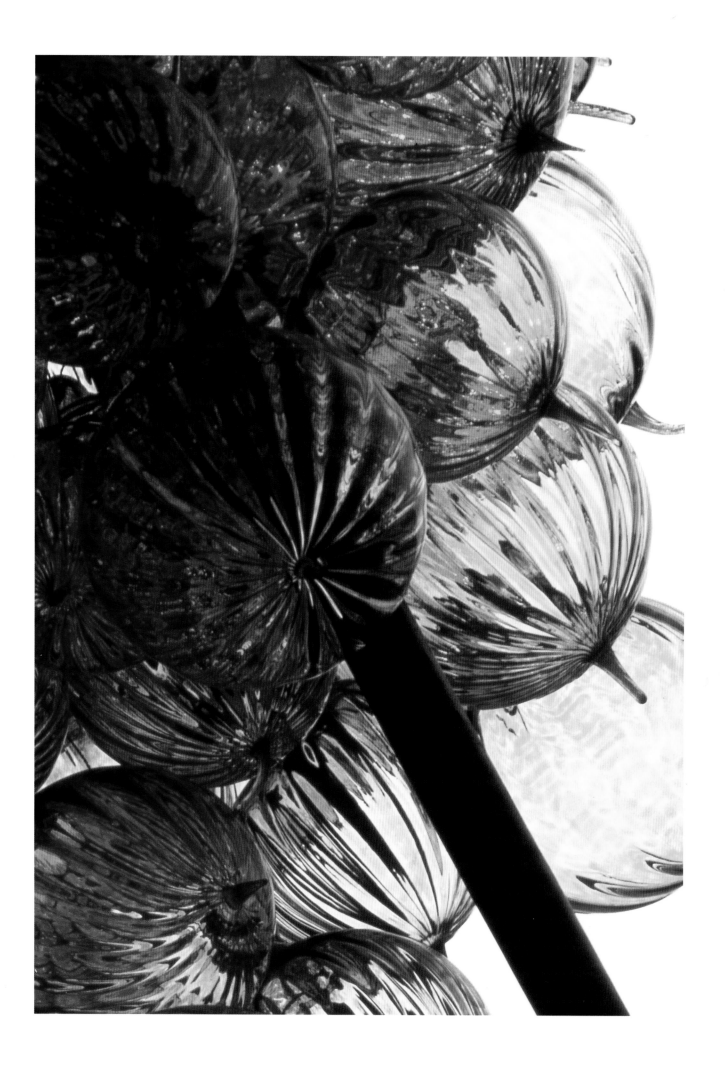

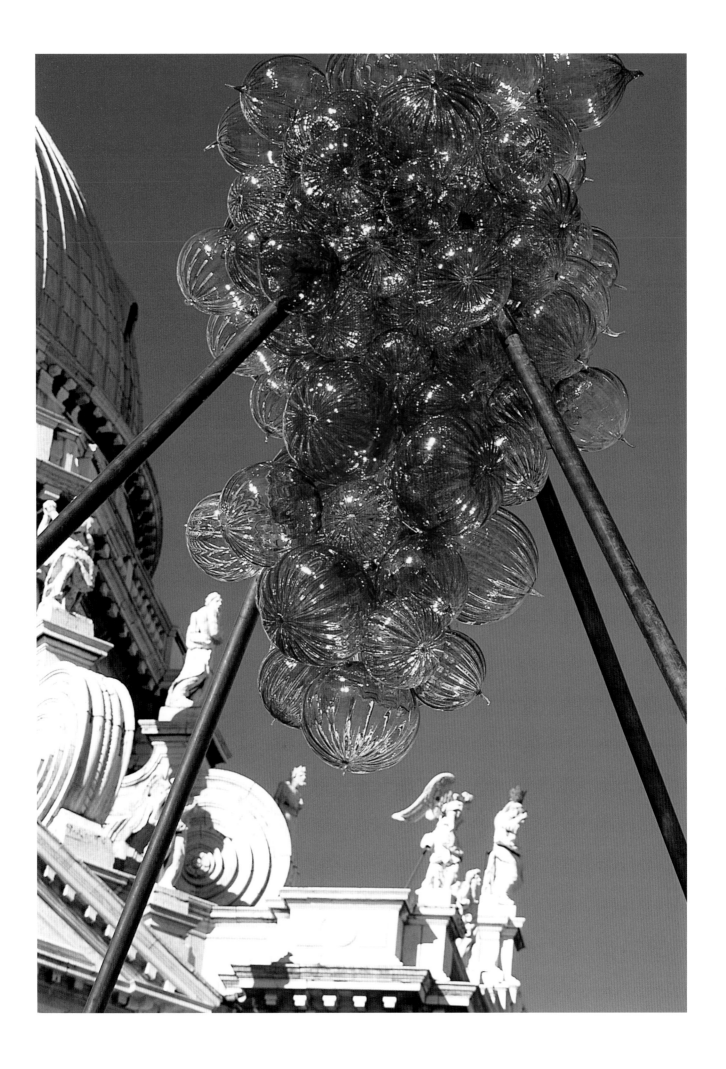

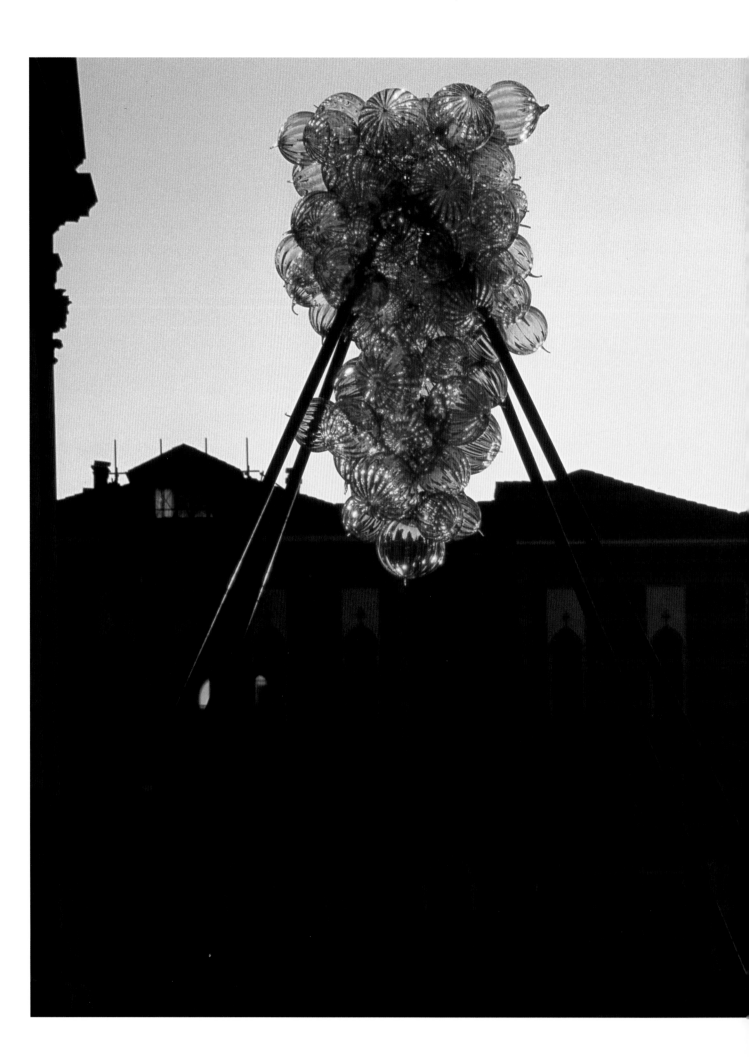

PALAZZO DUCALE

United States
508 pcs / 1272 lbs
9´ h x 8´ w

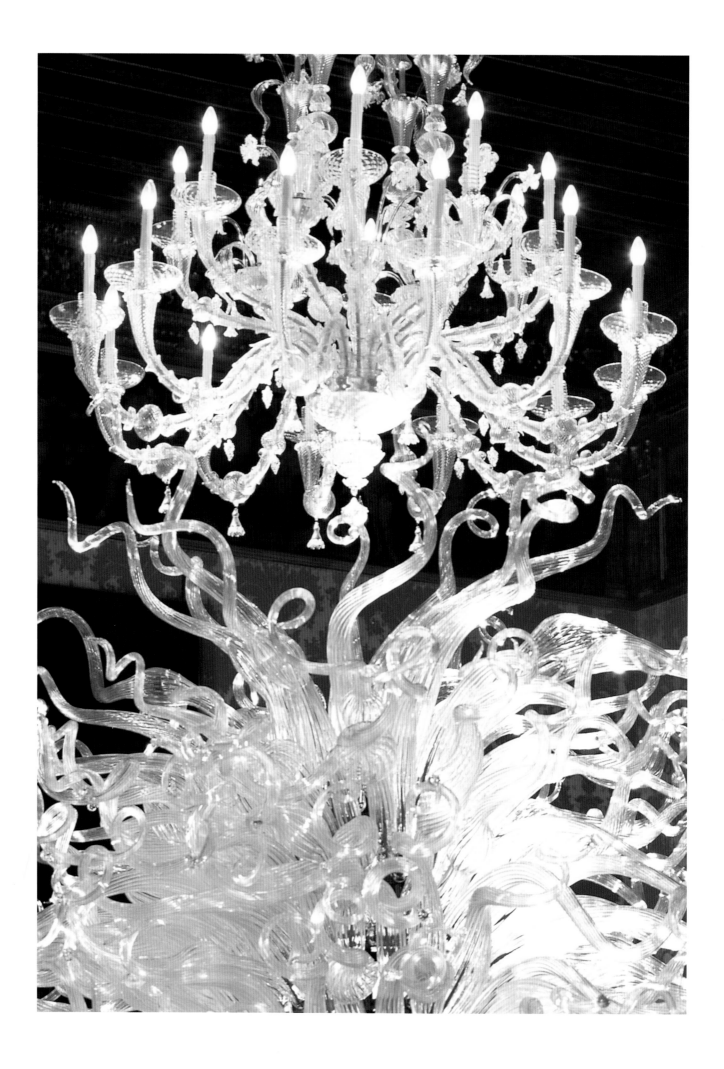

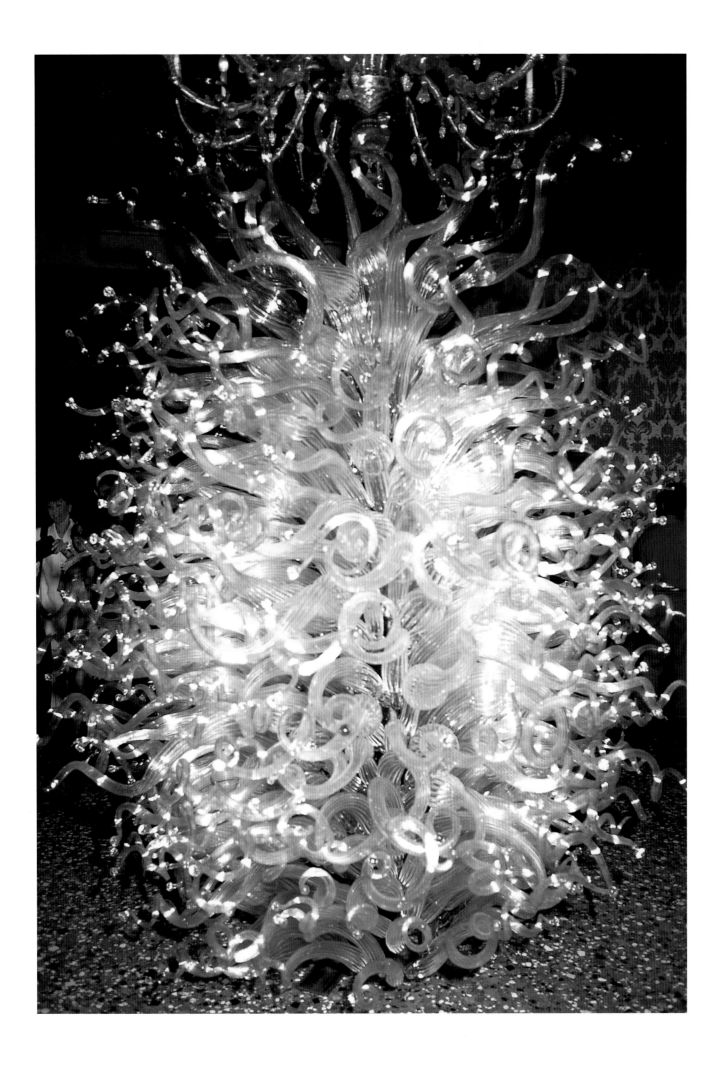

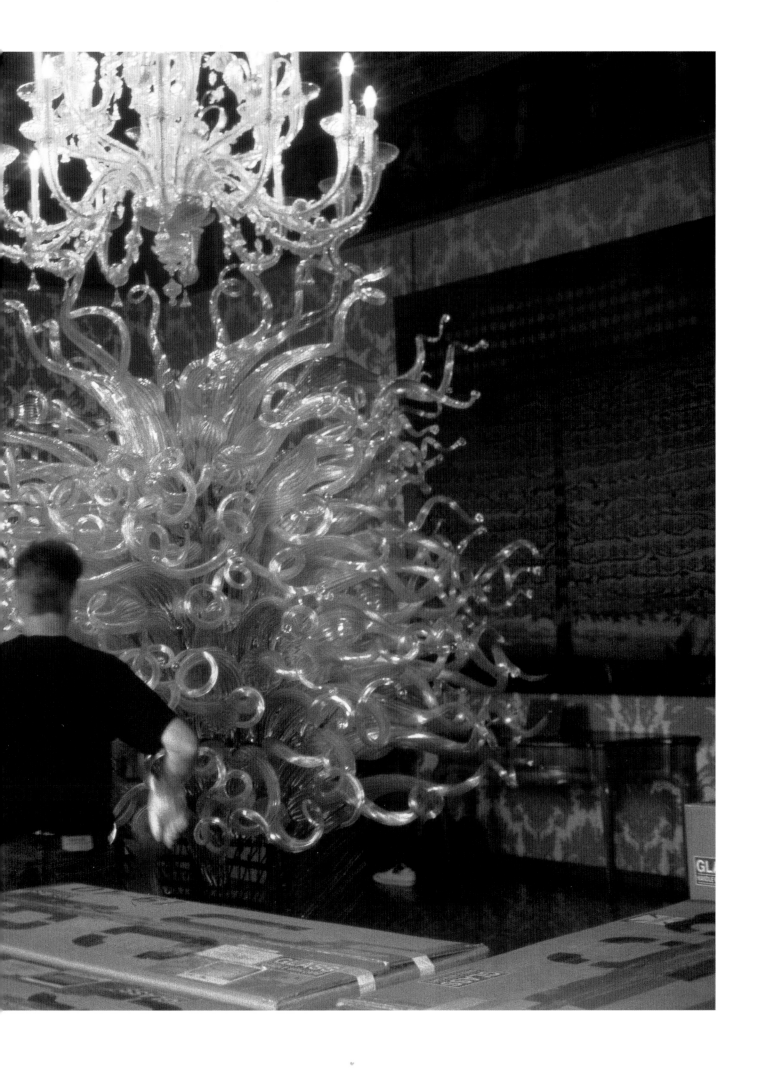

CHIOSTRO DI SANT' APOLLONIA

Finland

259 pcs / 1036 lbs.

5′ 5″ h x 7′ 4″ w

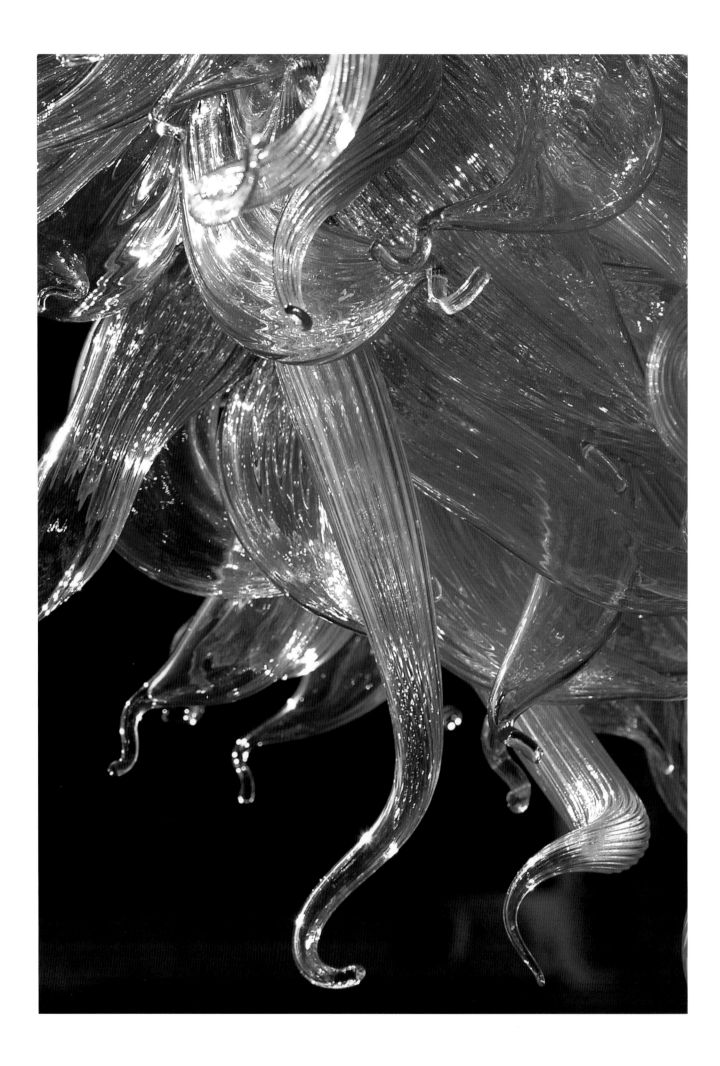

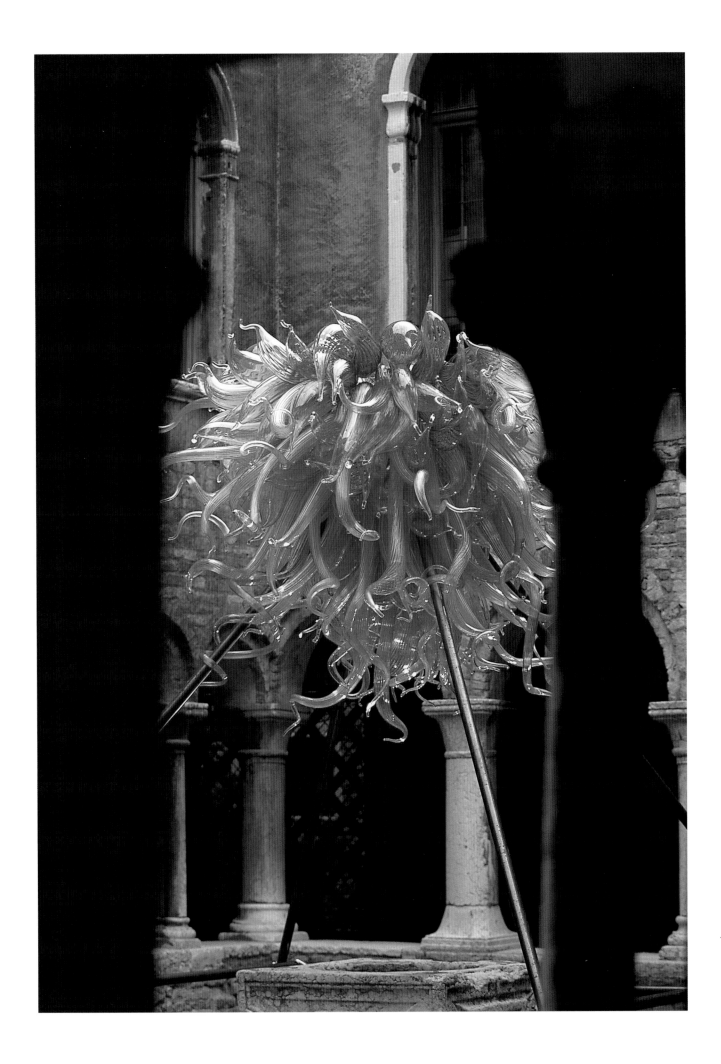

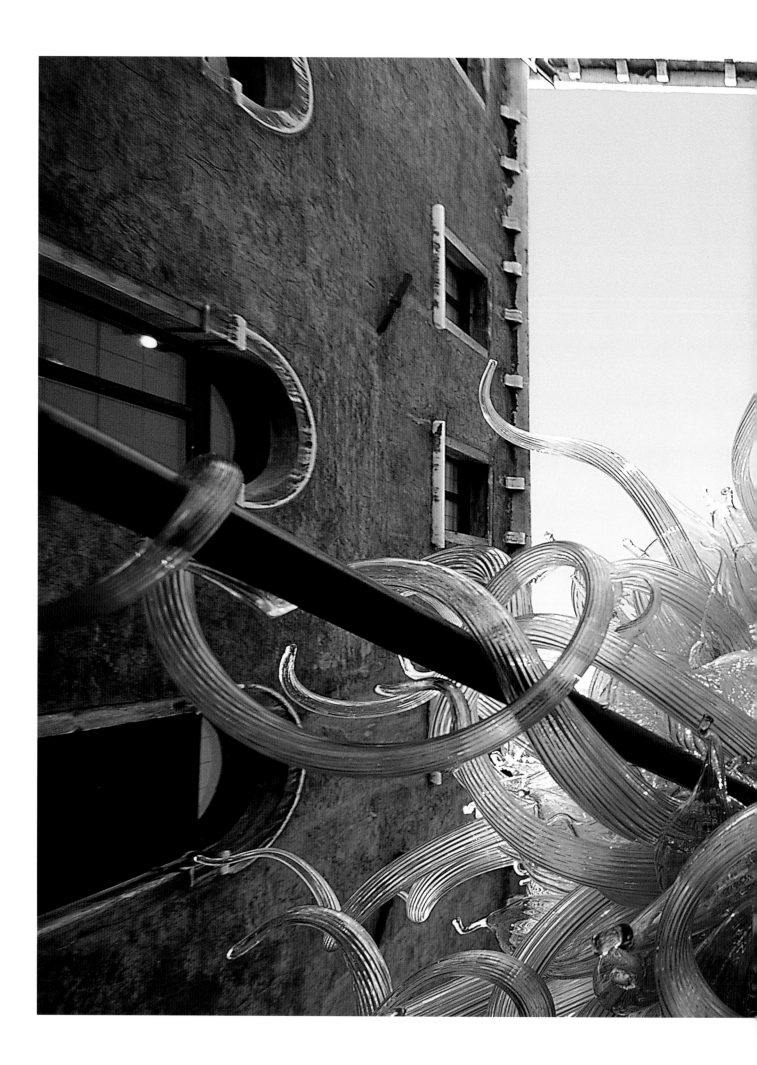

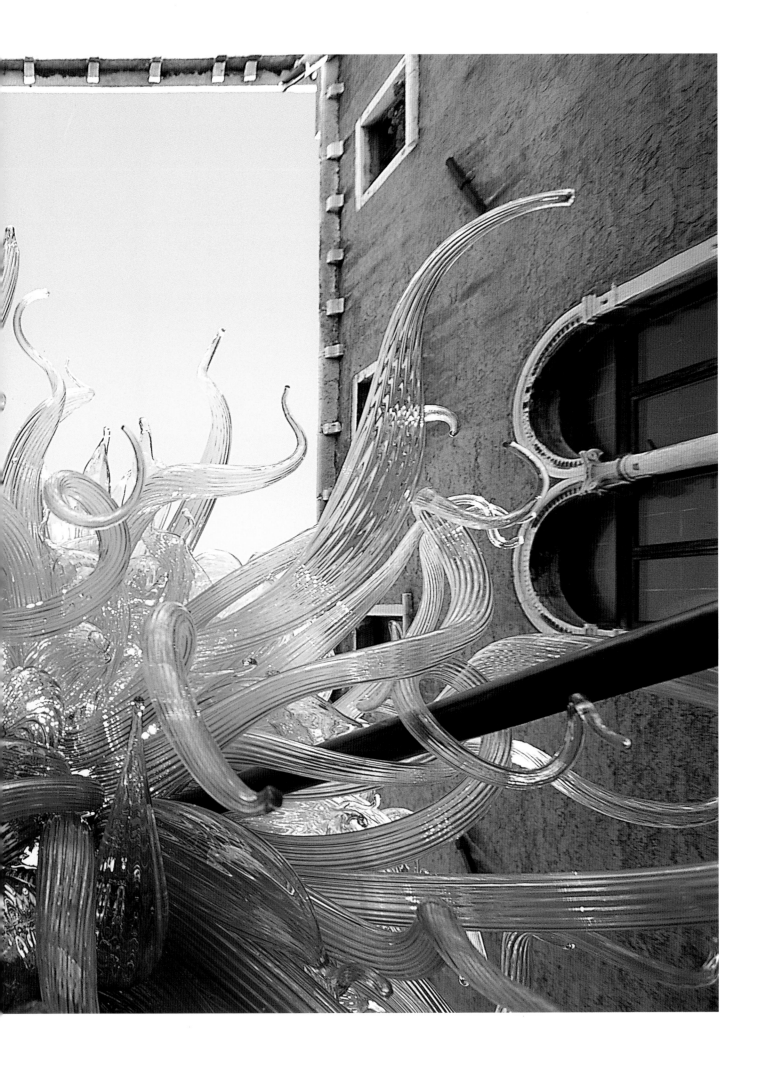

SQUERO DI SAN TROVASO

Finland

105 pcs/408 lbs

10´ h x 4´ w

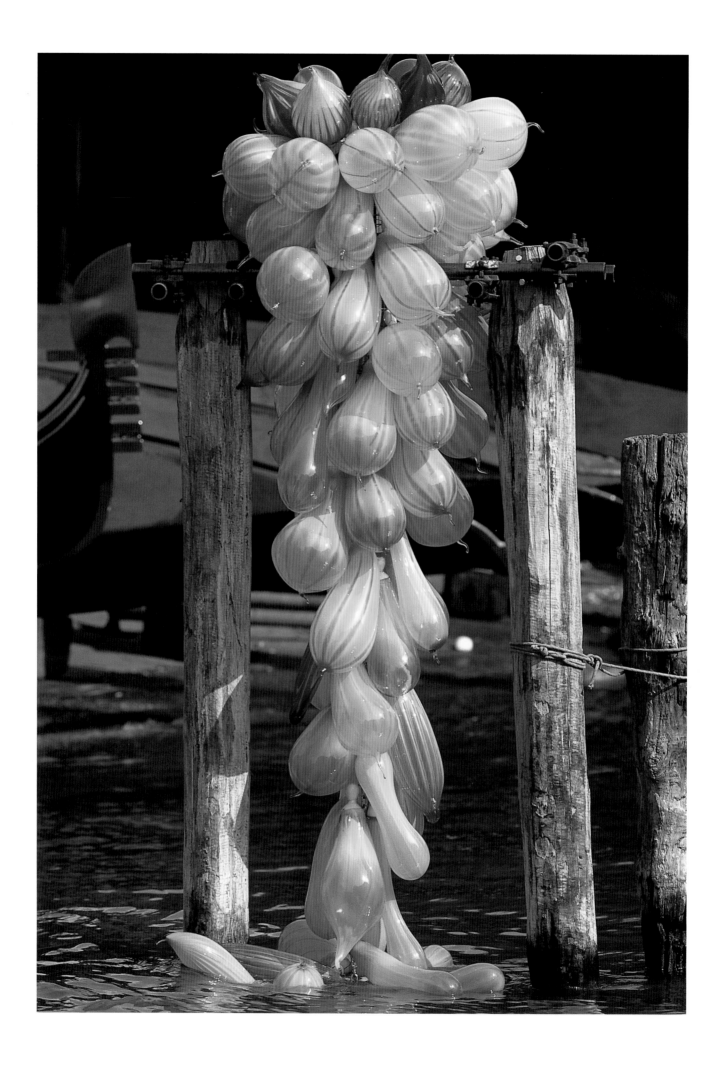

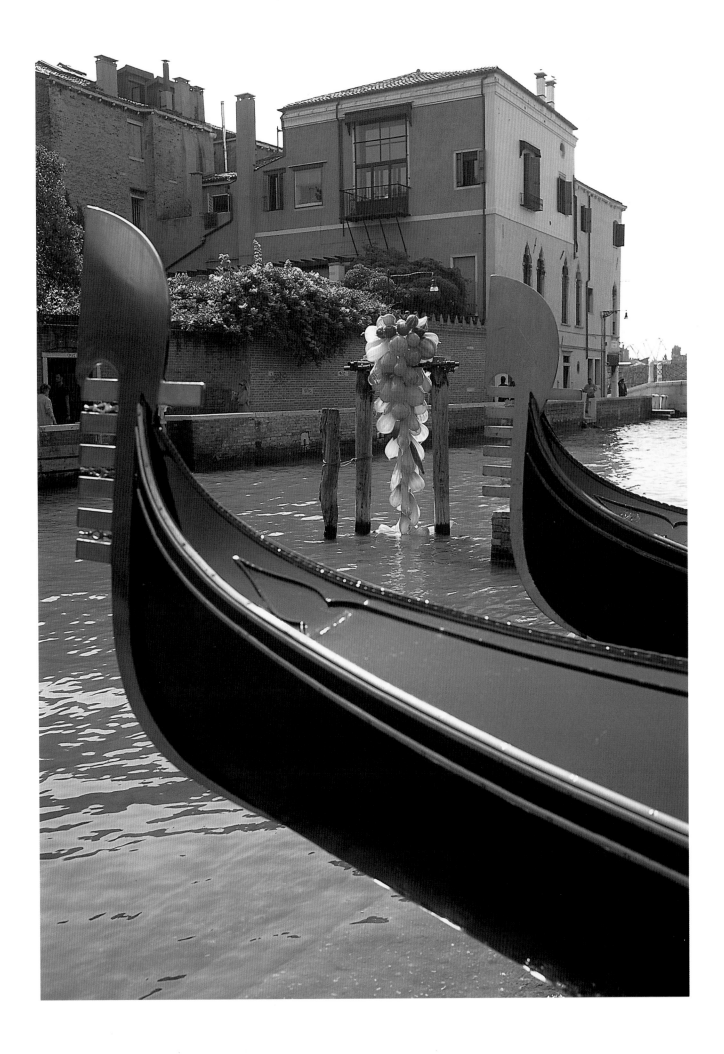

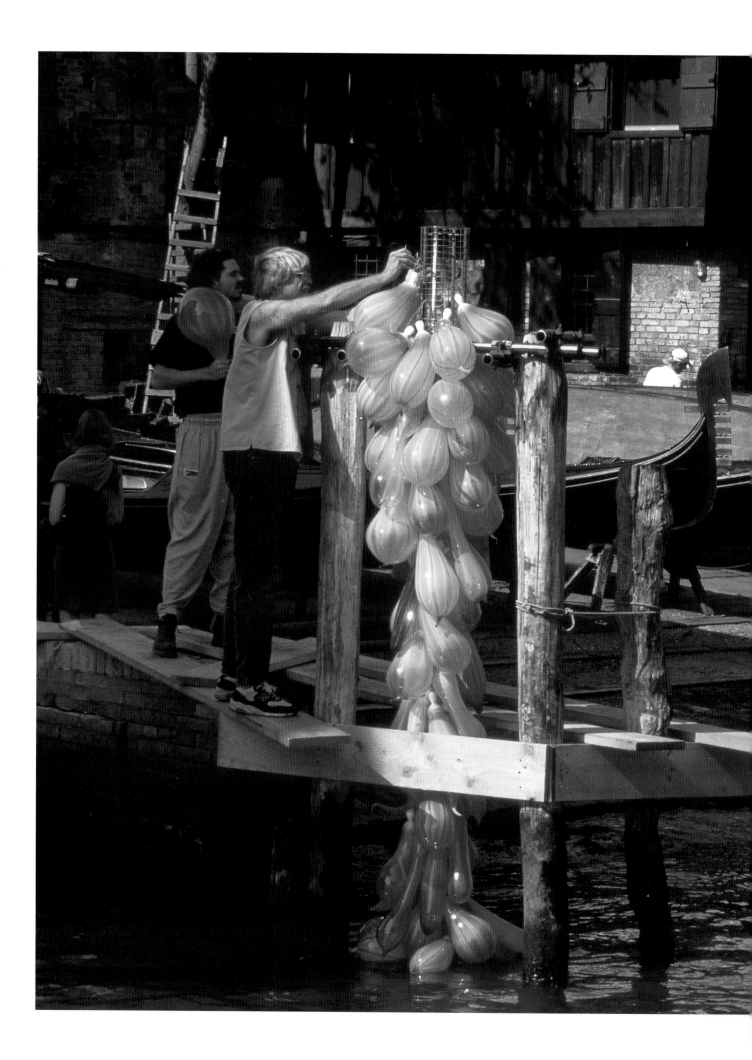

CAMPIELLO BARBARO

Mexico

216 pcs / 678 lbs

7´ h x 6´ 6″ w

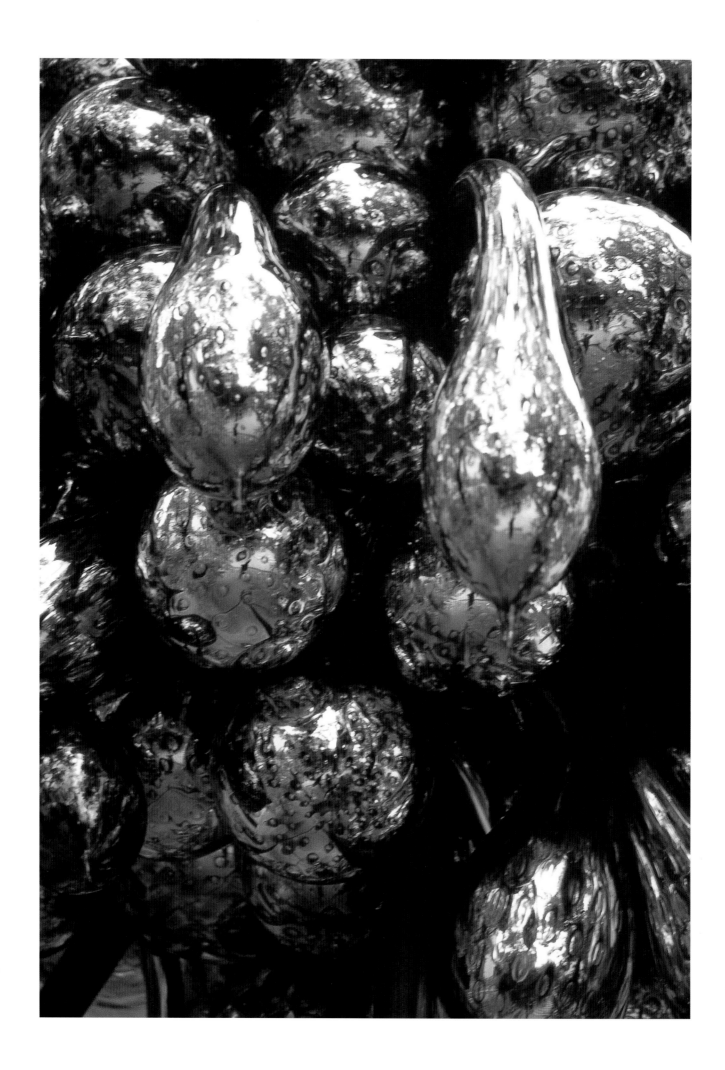

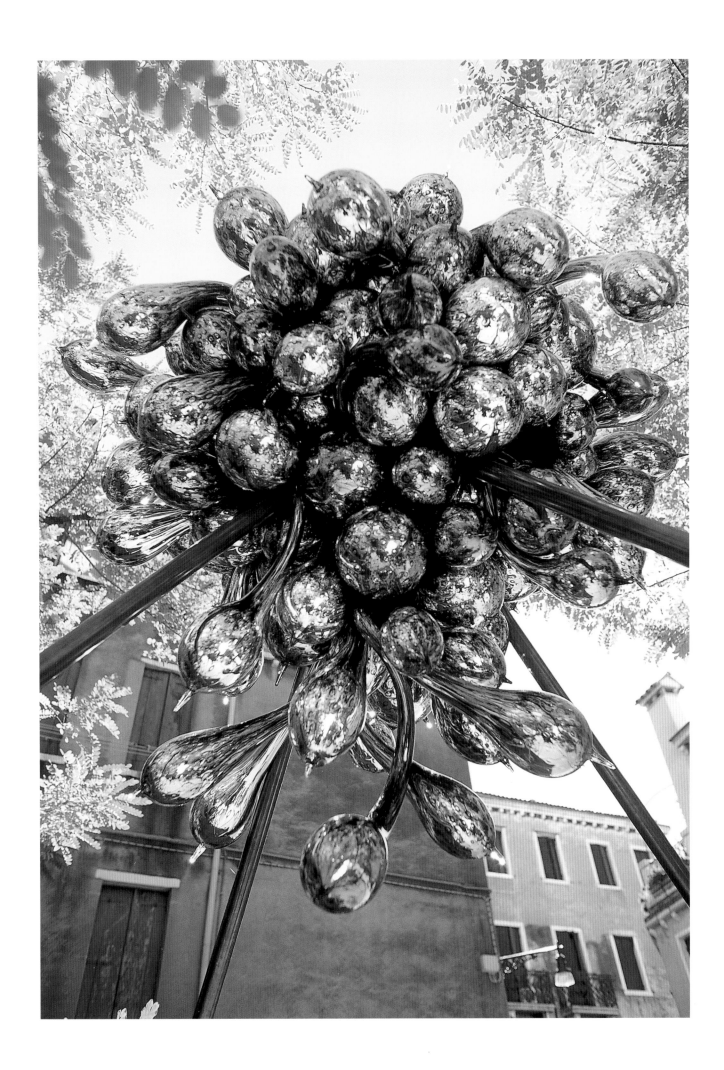

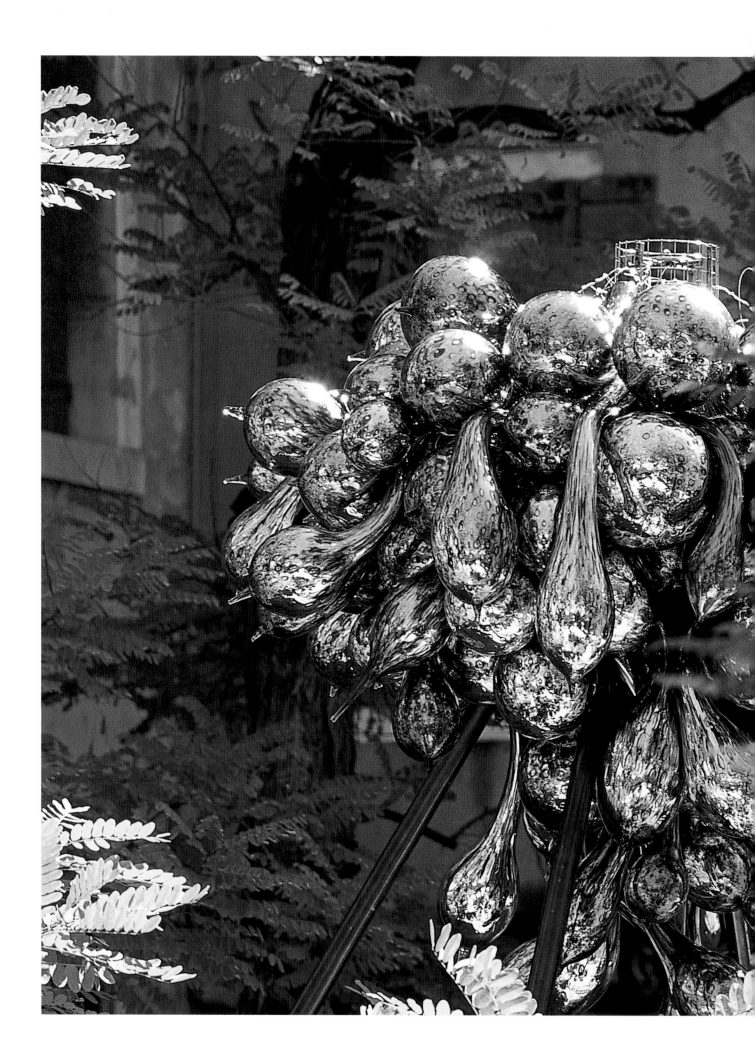

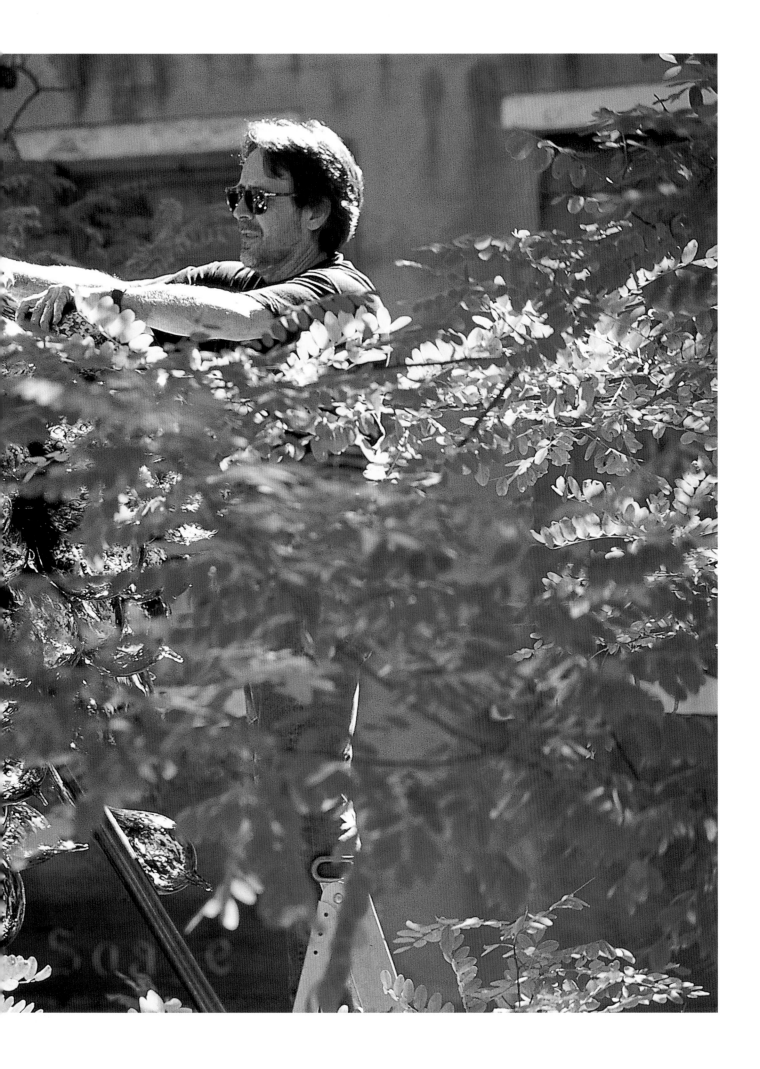

PALAZZO DI LOREDANA BALBONI

Mexico

228 pcs/799 lbs

10´7˝ h x 6´6˝ w

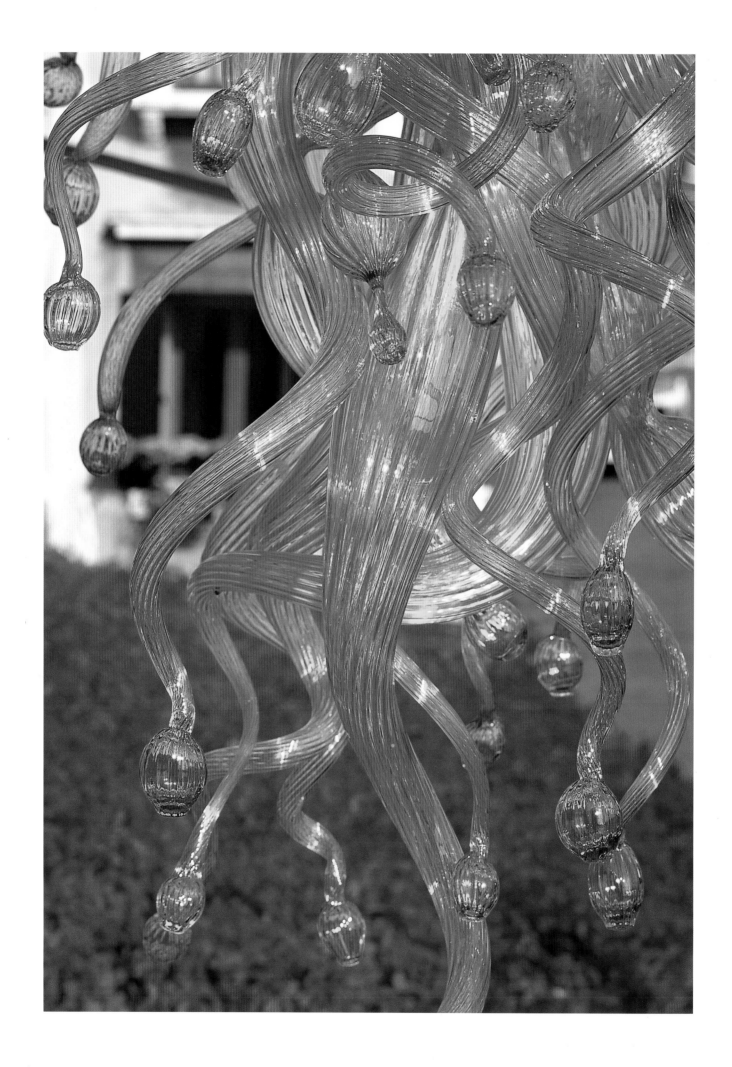

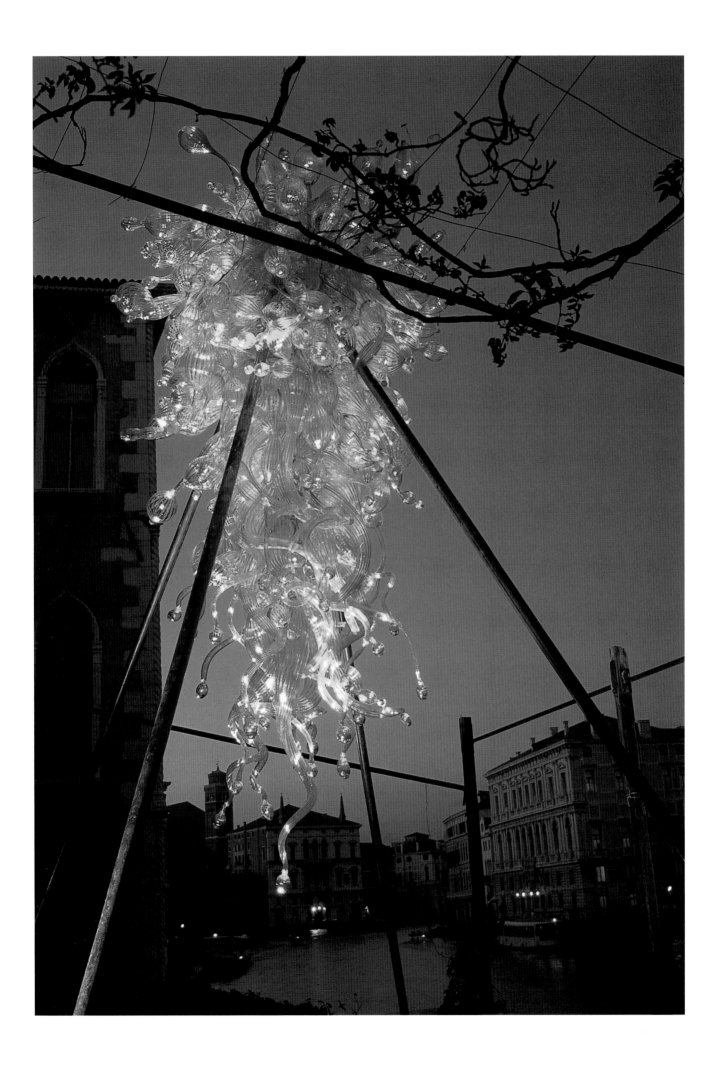

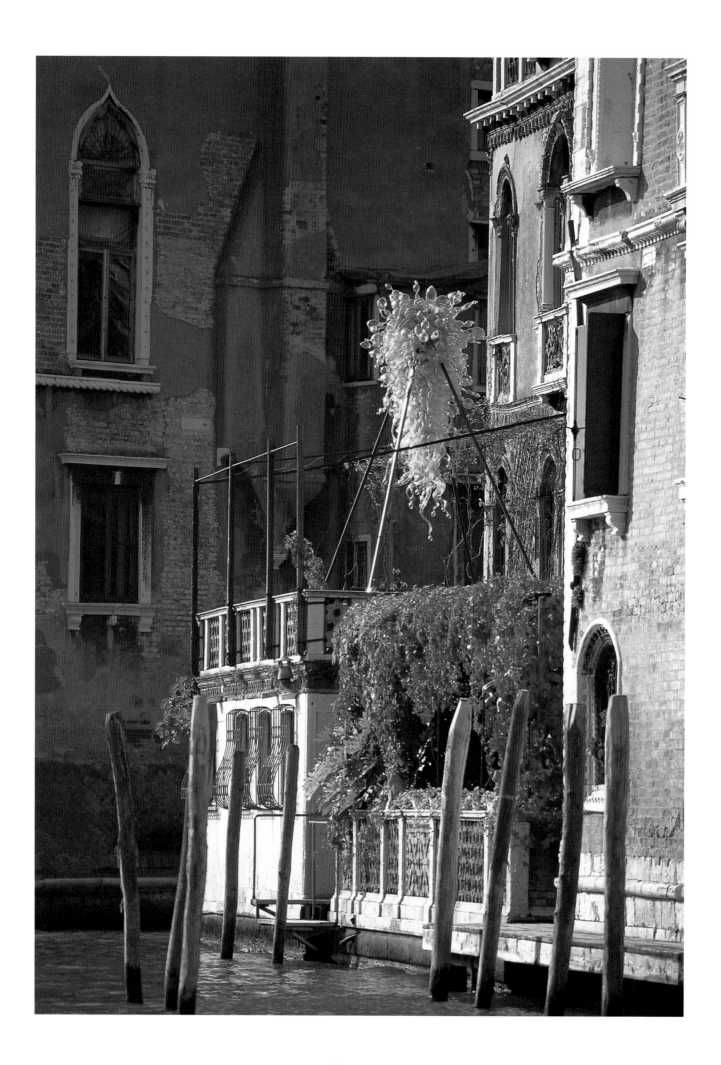

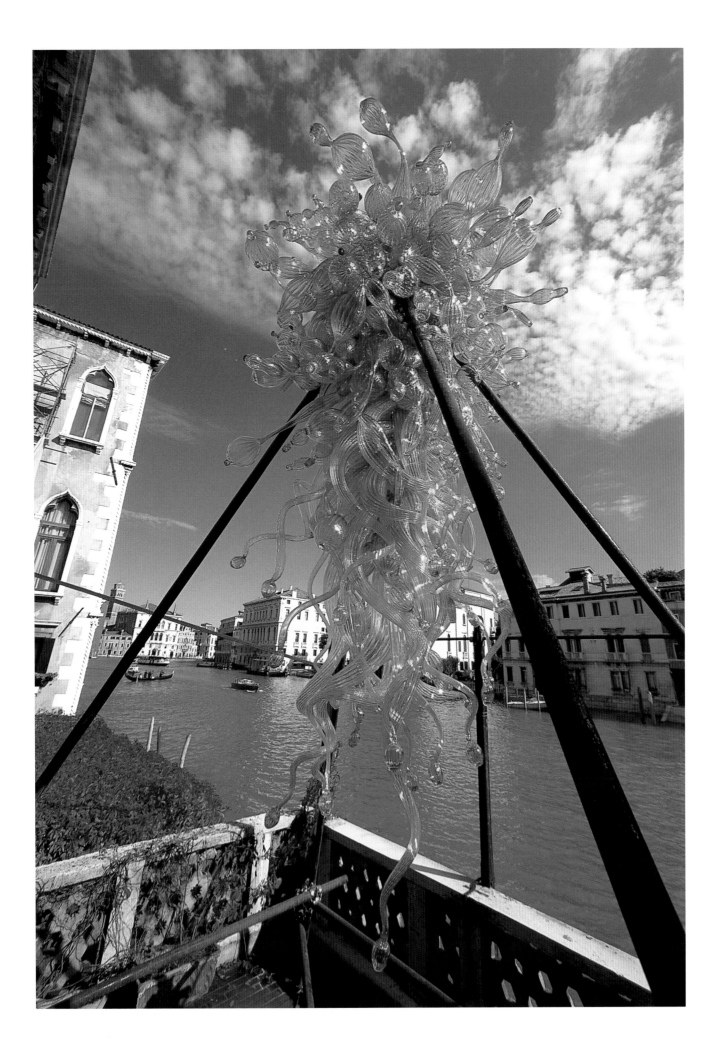

RIO DELLE TORRESELLE

Finland

185 pcs / 374 lbs

6′ 9″ h x 8′ 2″ w

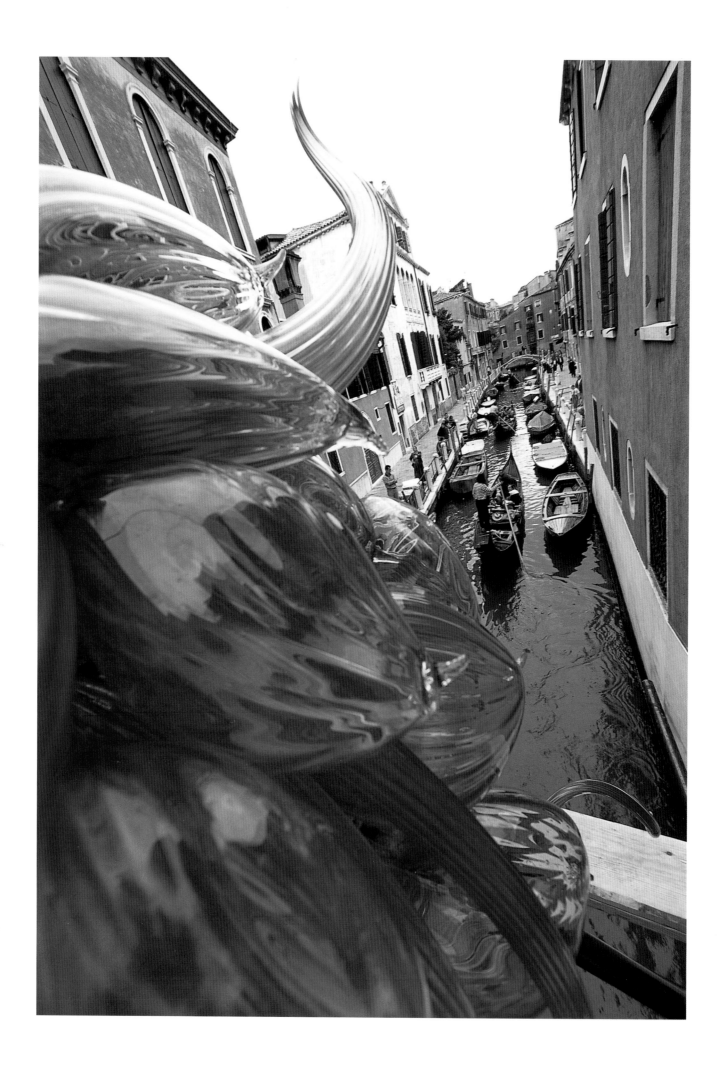

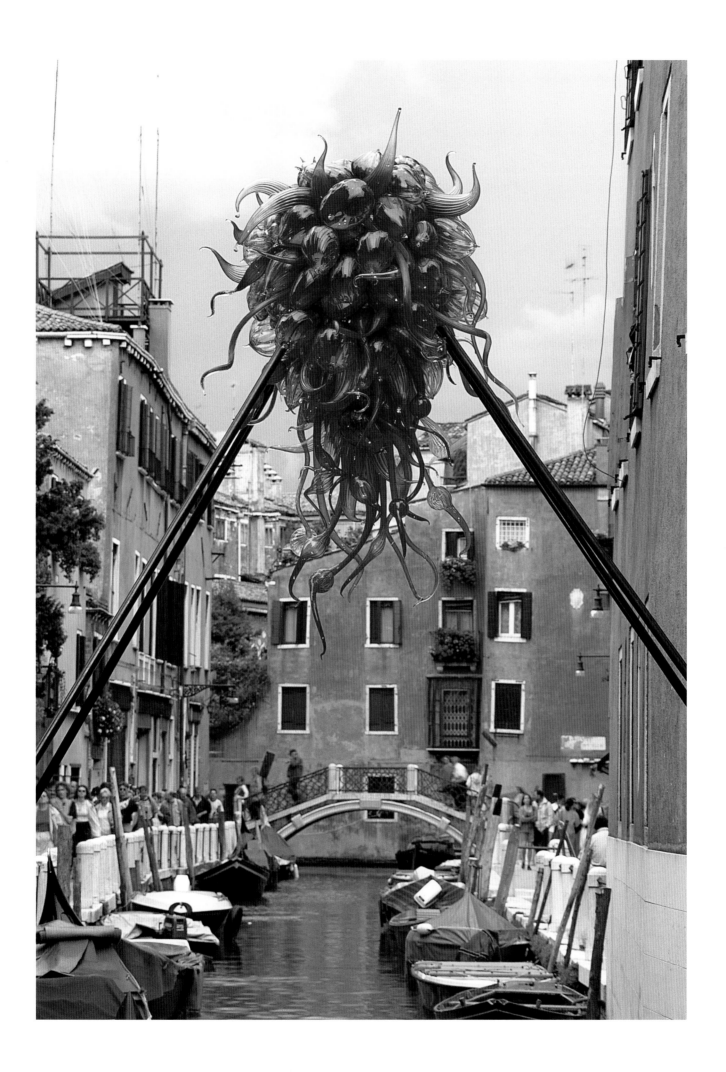

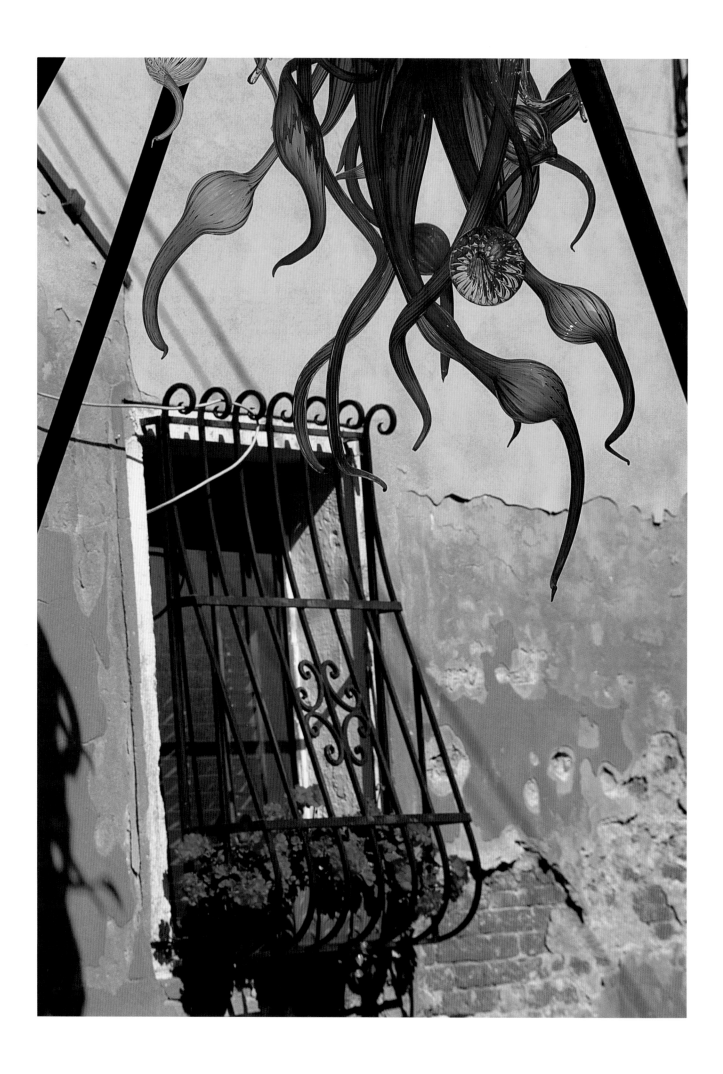

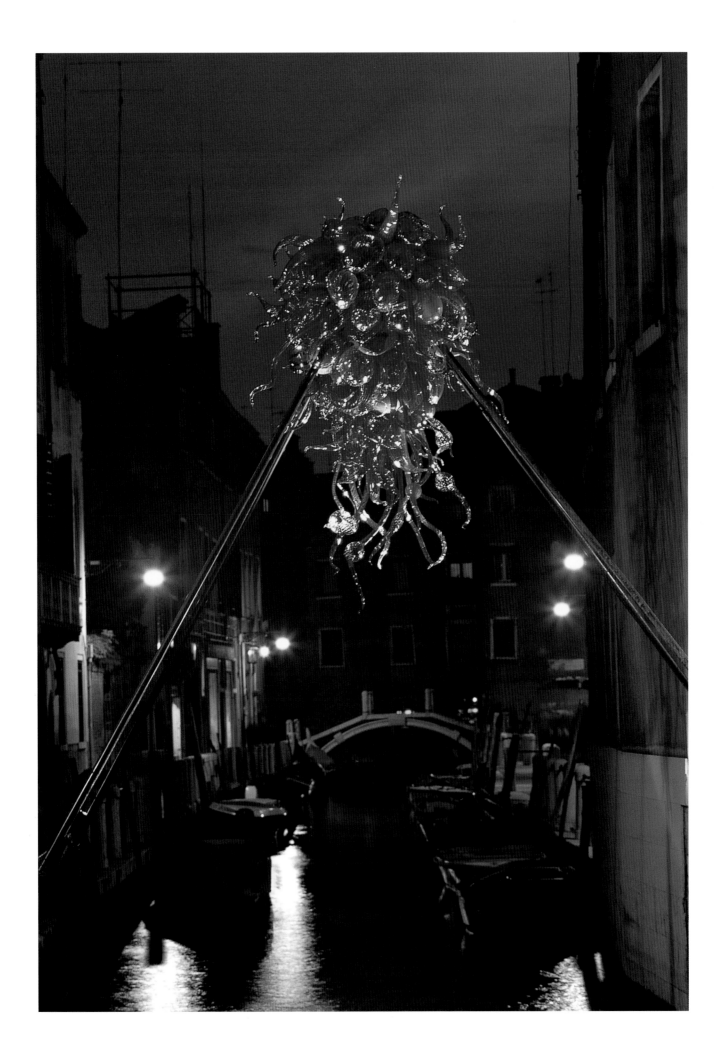

CAMPO SAN MAURIZIO

Mexico

98 pcs / 338 lbs

5´ 6˝ h x 4´ w

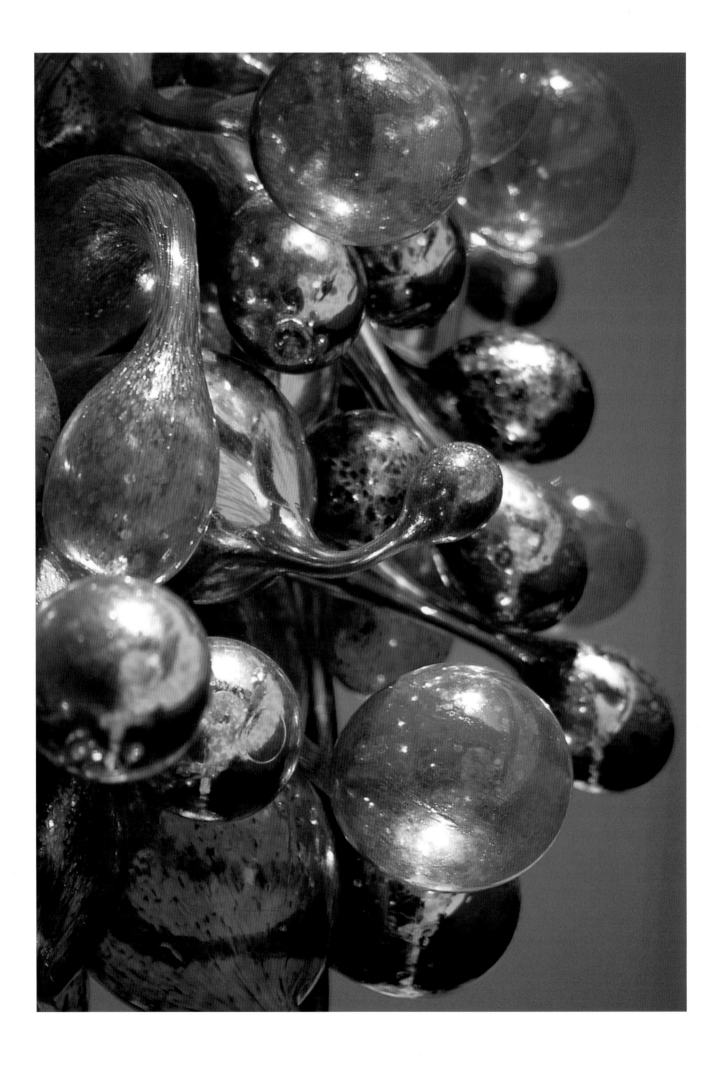

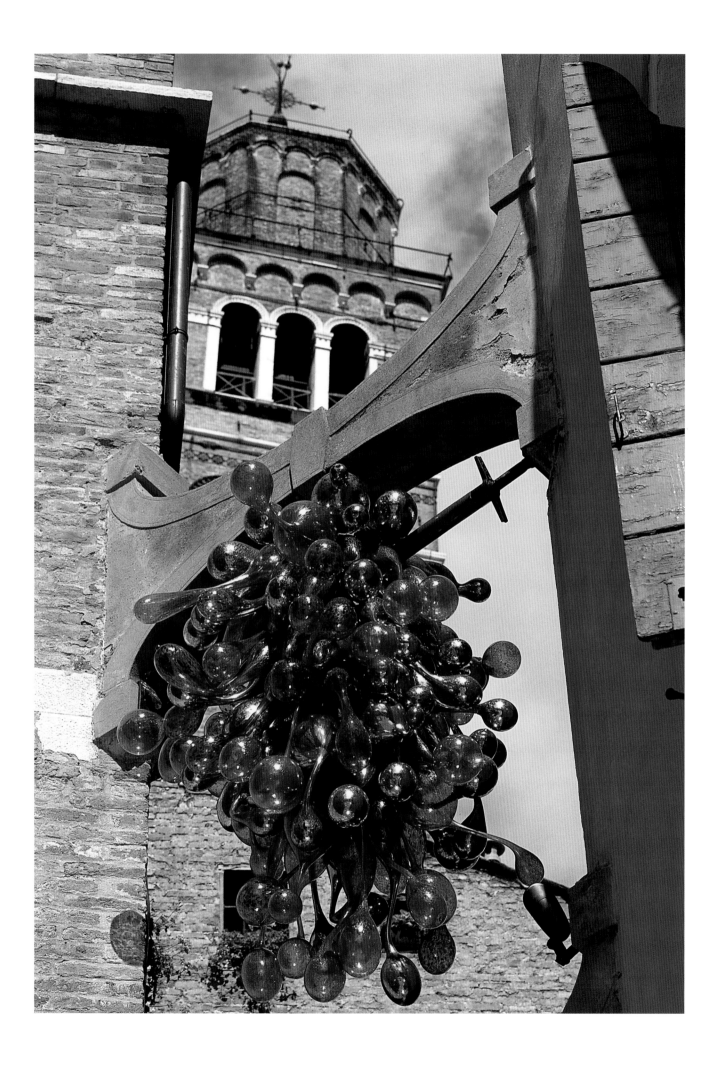

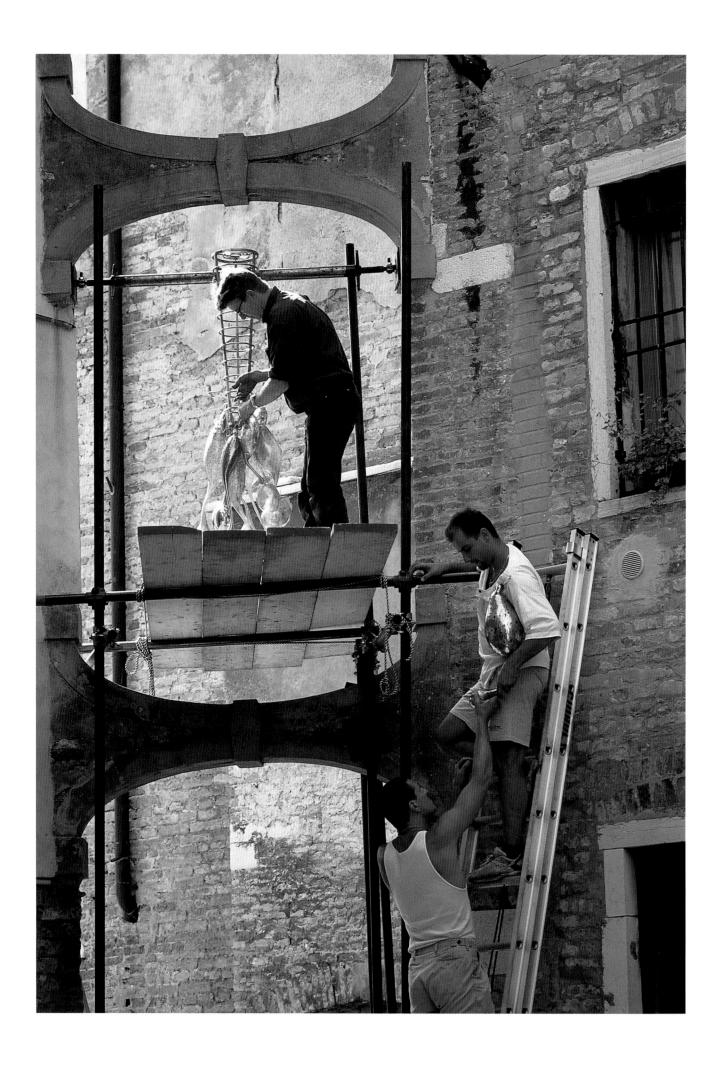

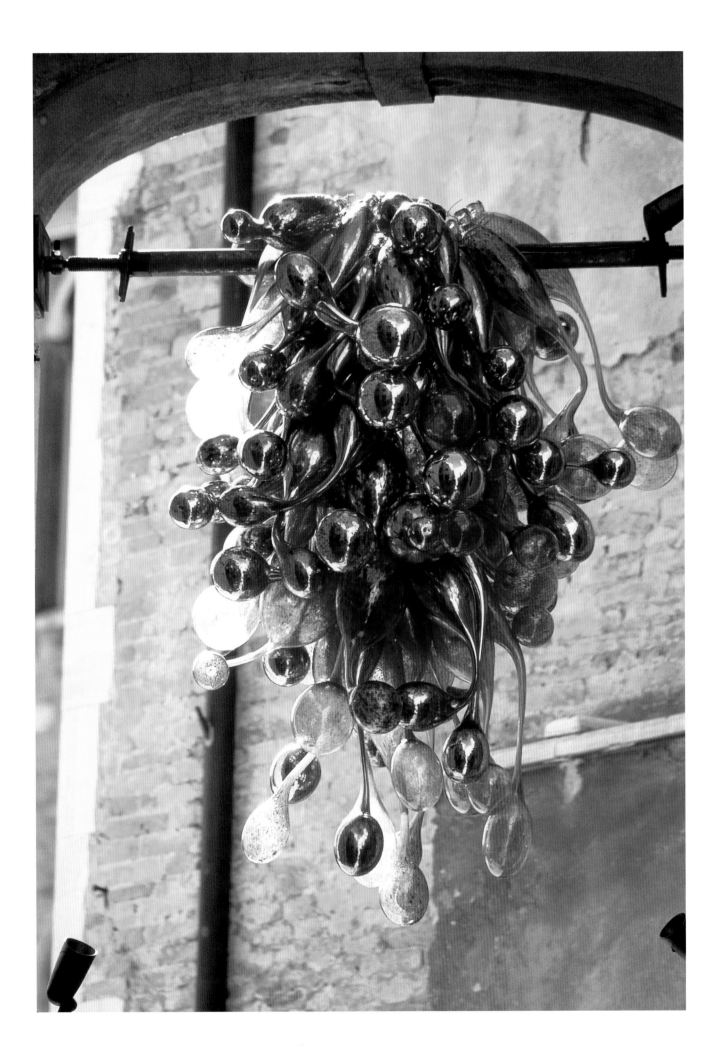

GIARDINO SAMMARTINI

Mexico

183 pcs / 1195 lbs

12´ 7˝ h x 4´ w

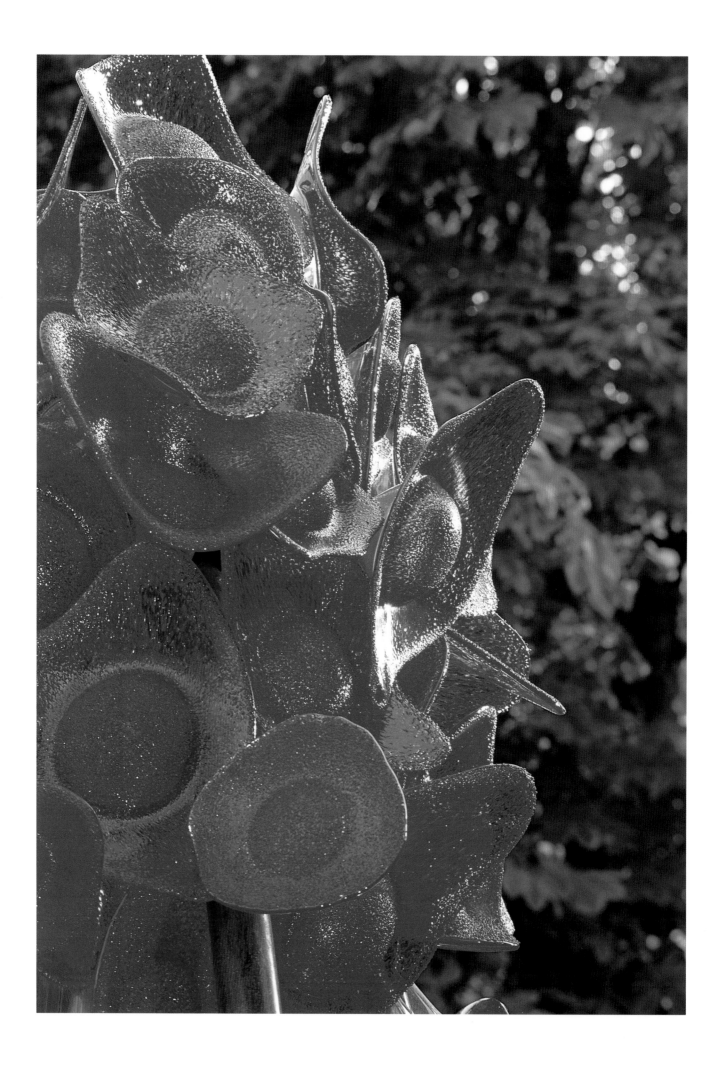

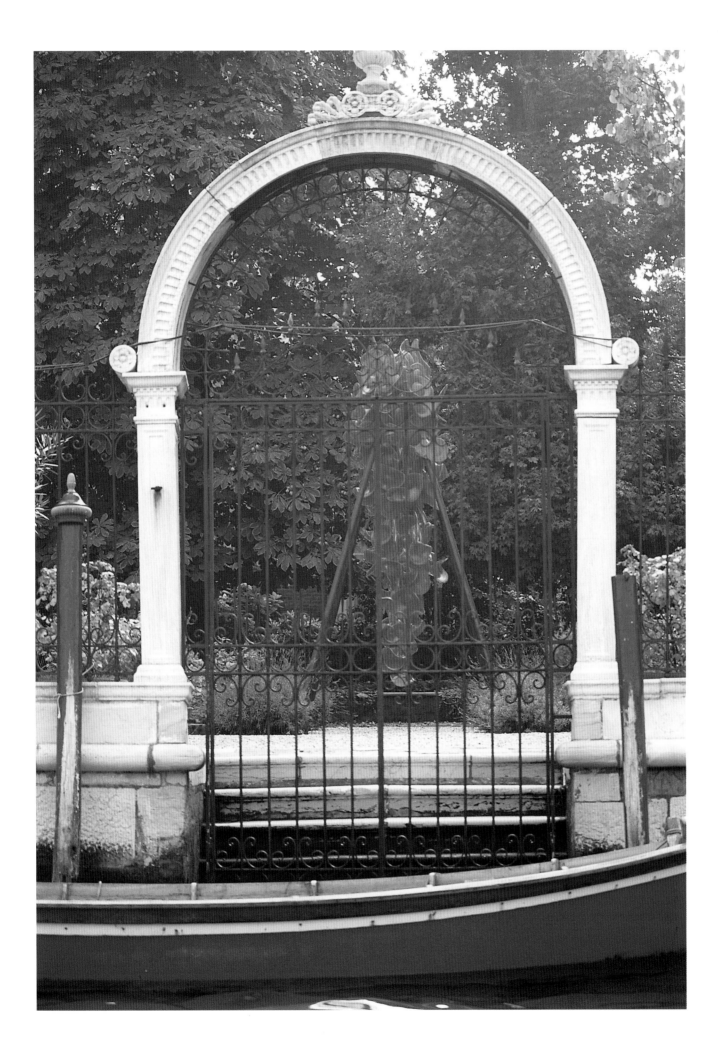

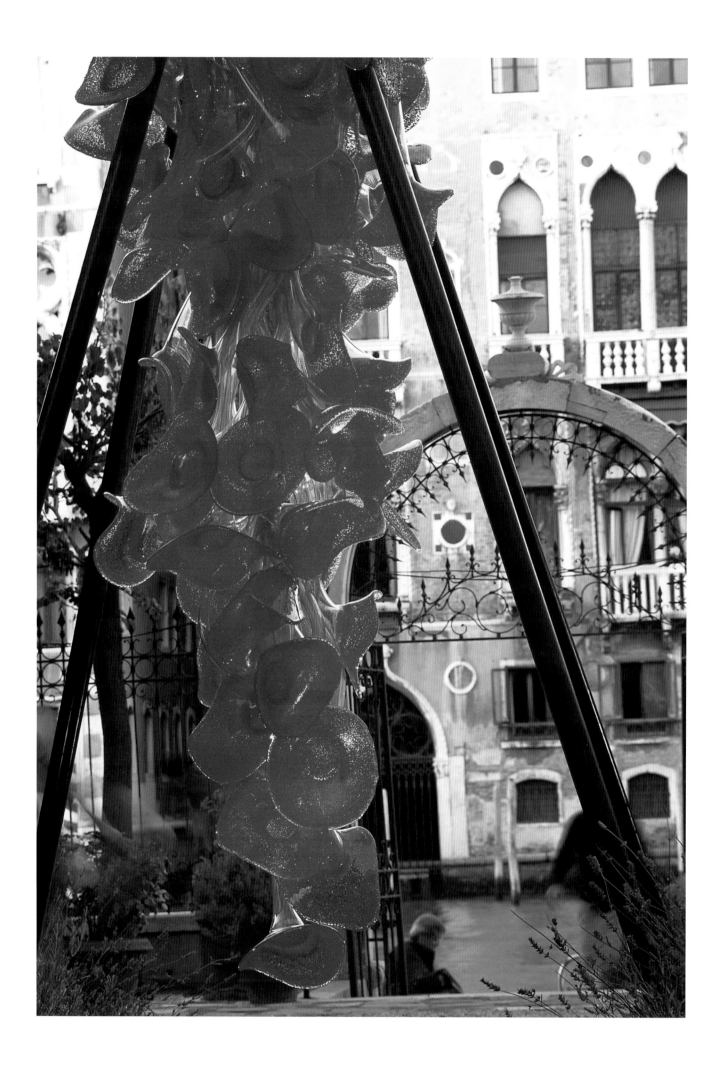

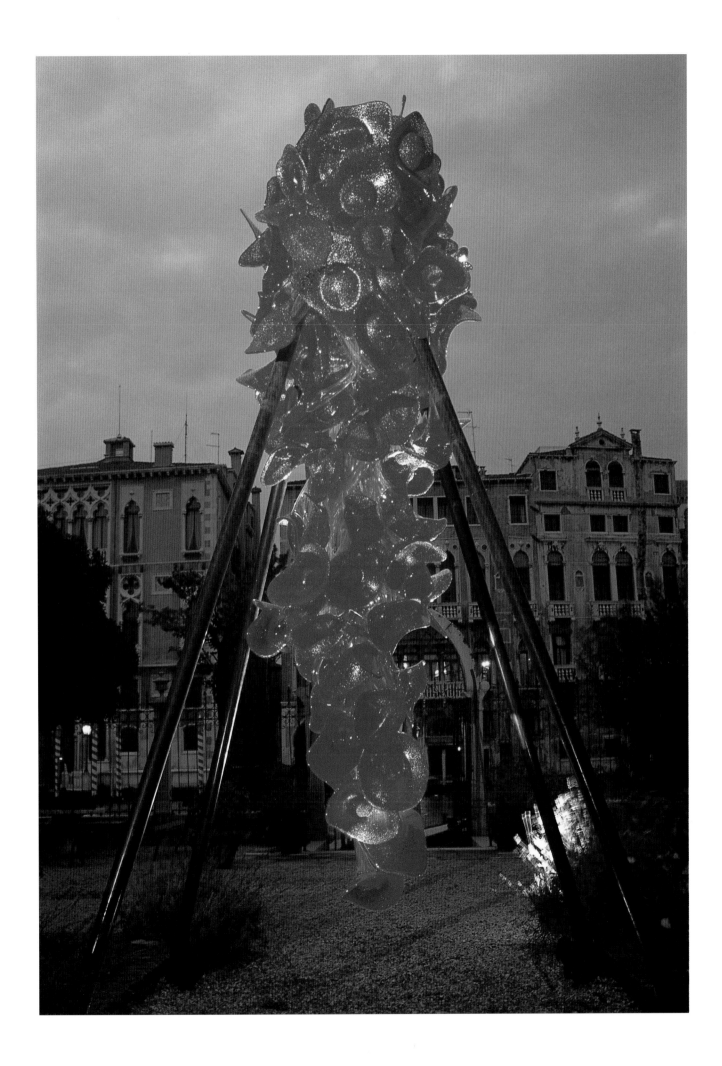

PONTI DUODO O BARBARIGO

Mexico

210 pcs / 630 lbs

11´ h x 4´ w

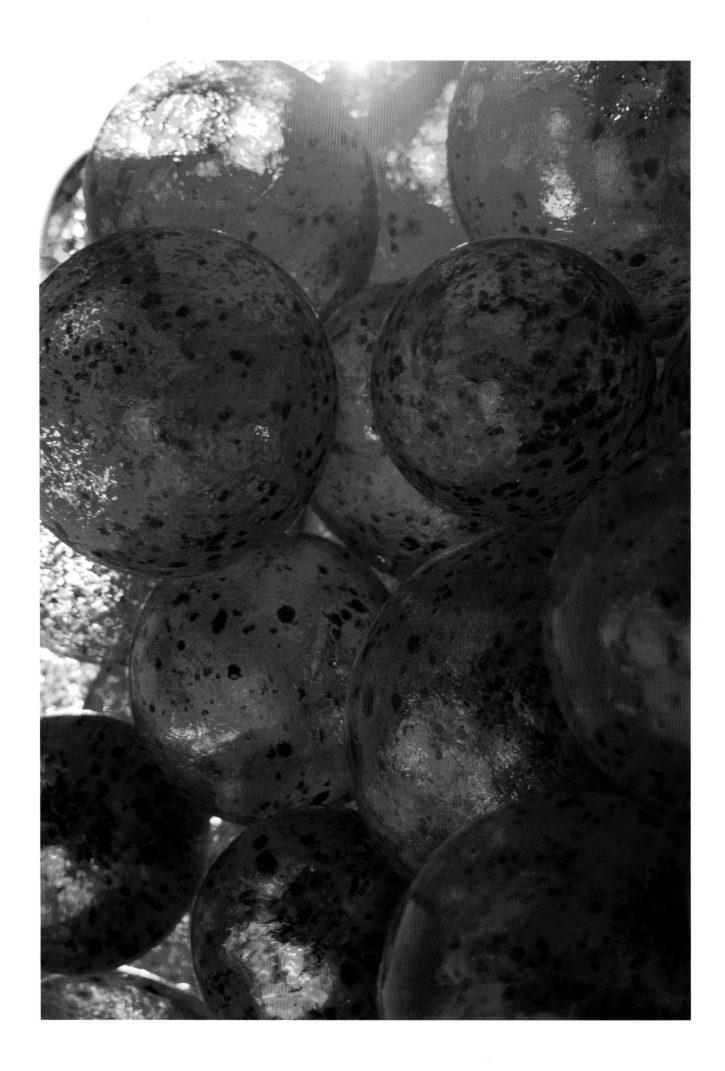

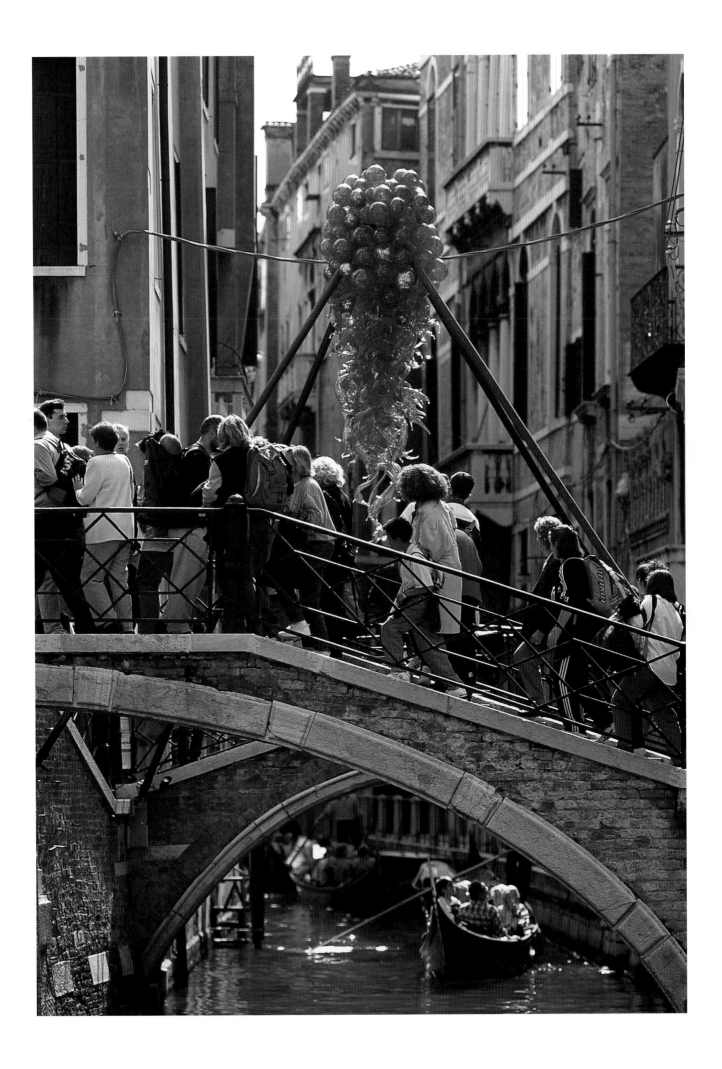

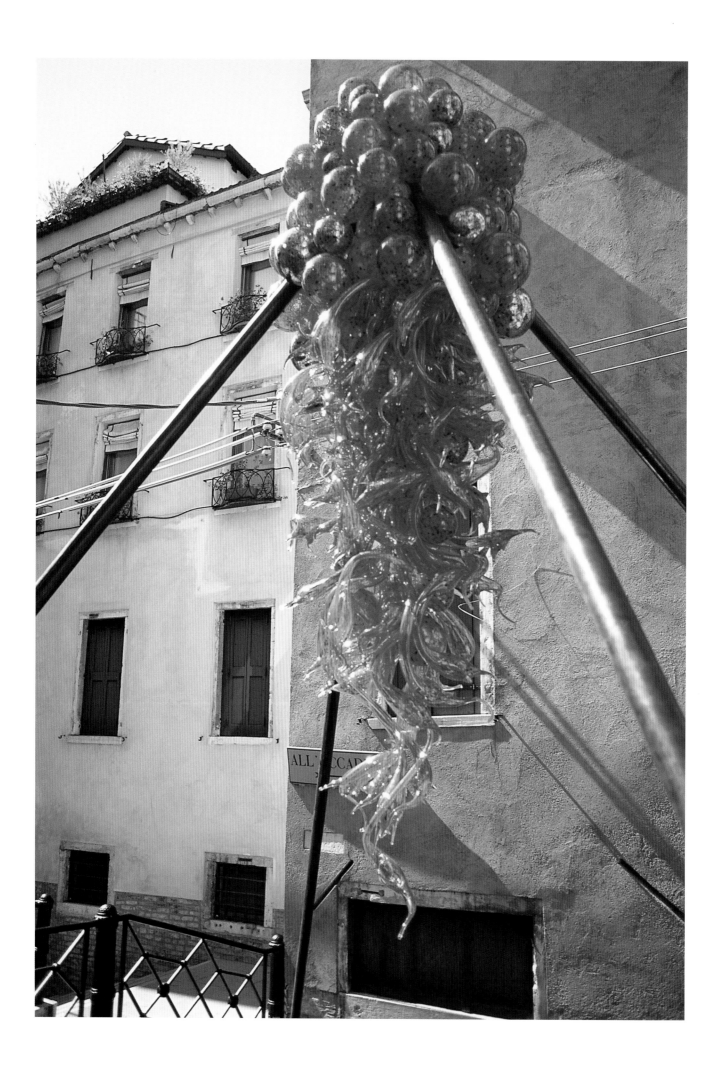

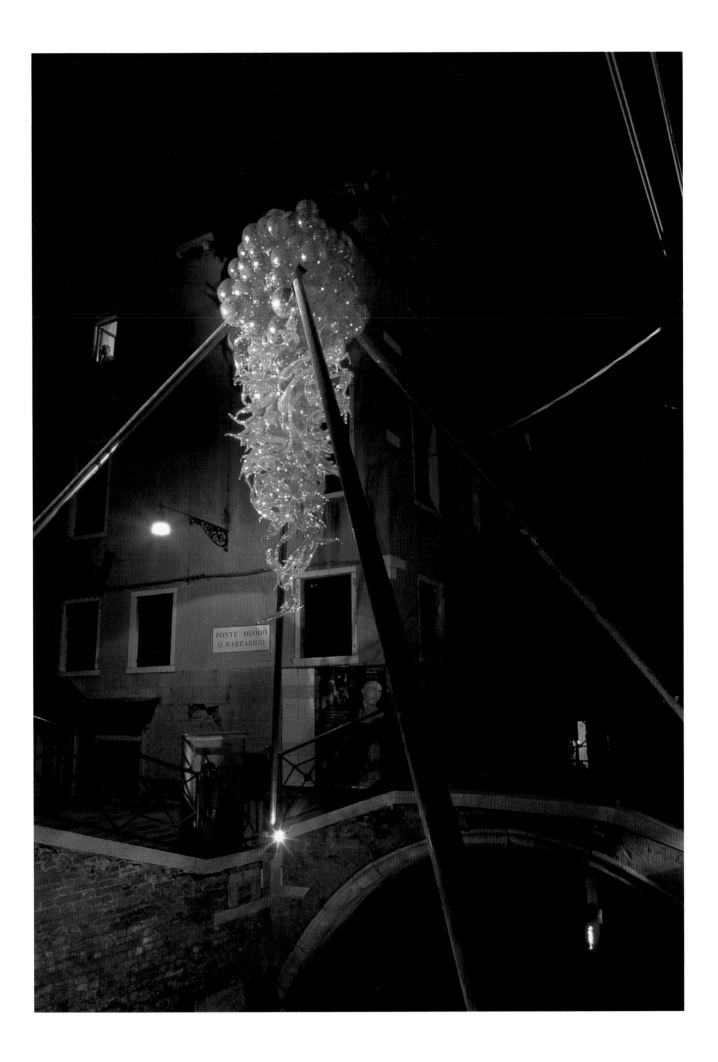

ISOLA DI SAN GIACOMO IN PALUDE

Italy

236 pcs / 944 lbs

8´7˝ h x 7´2˝ w

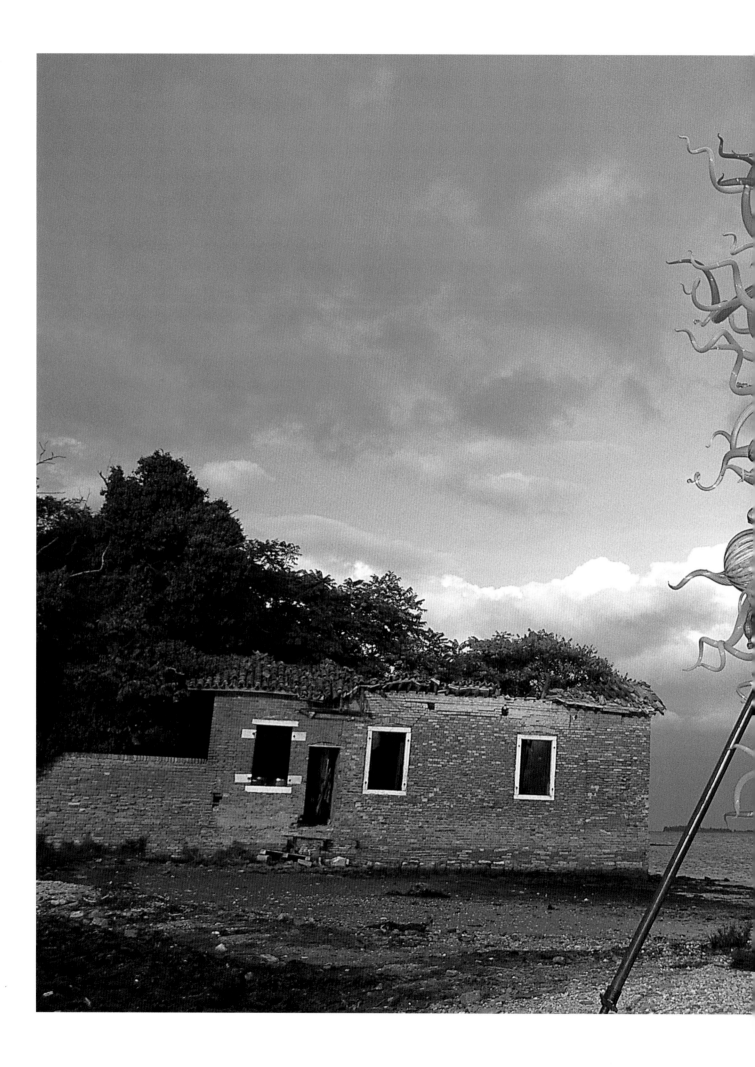

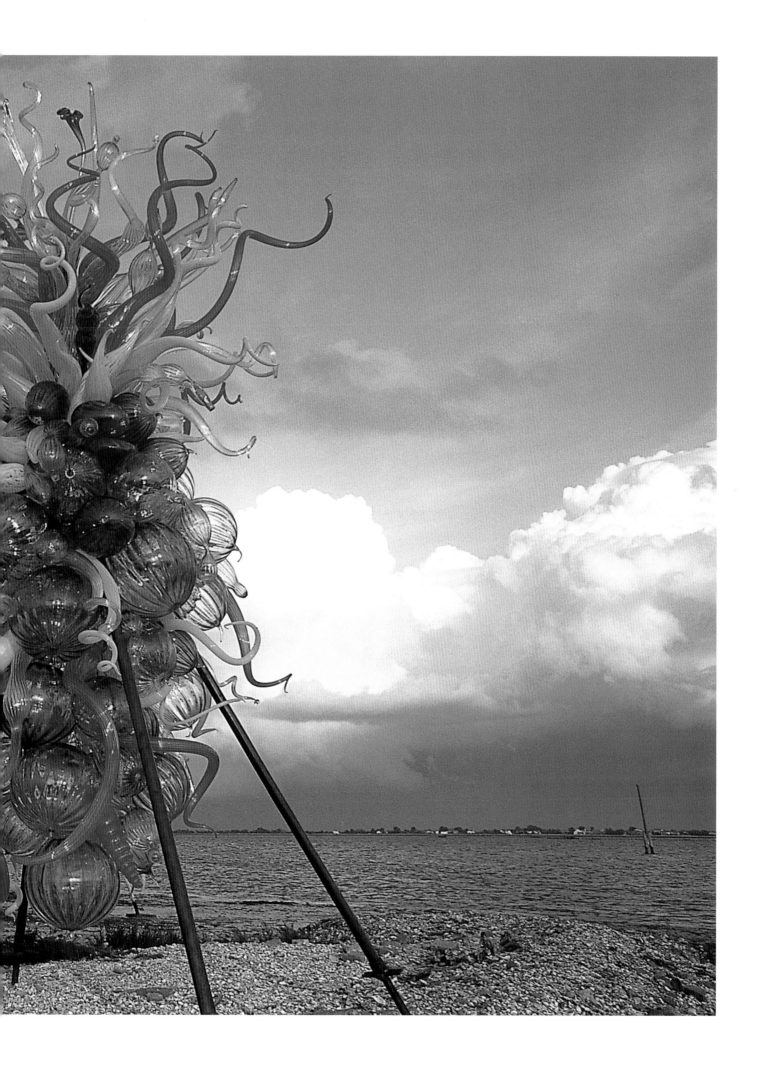

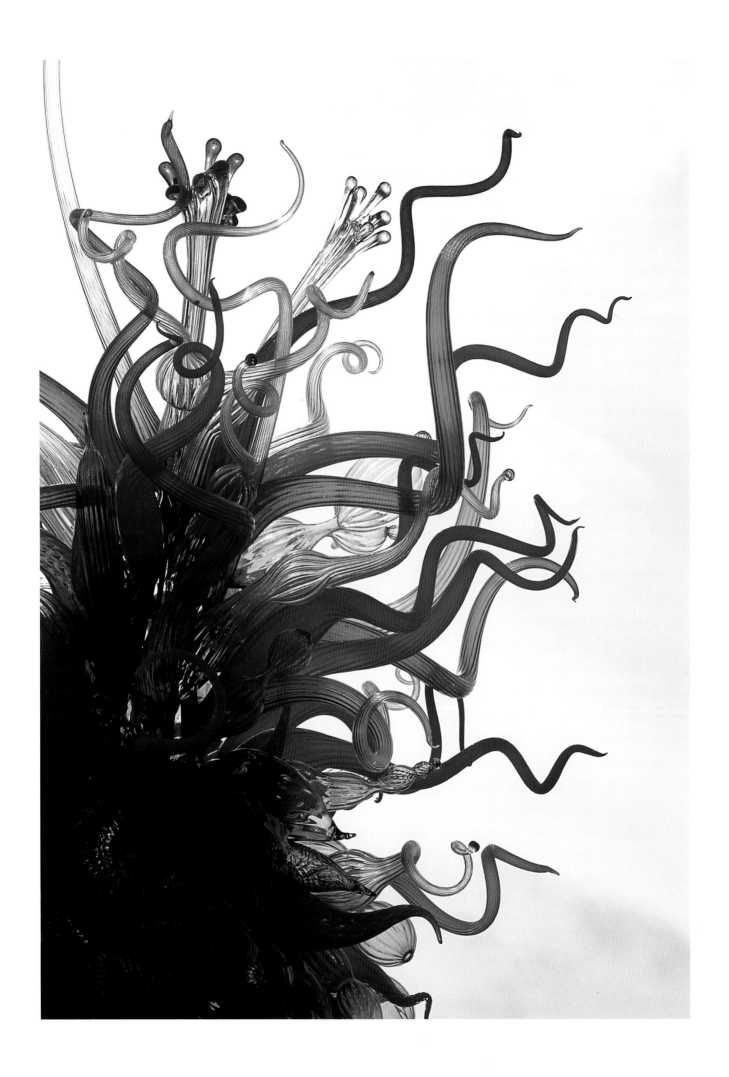

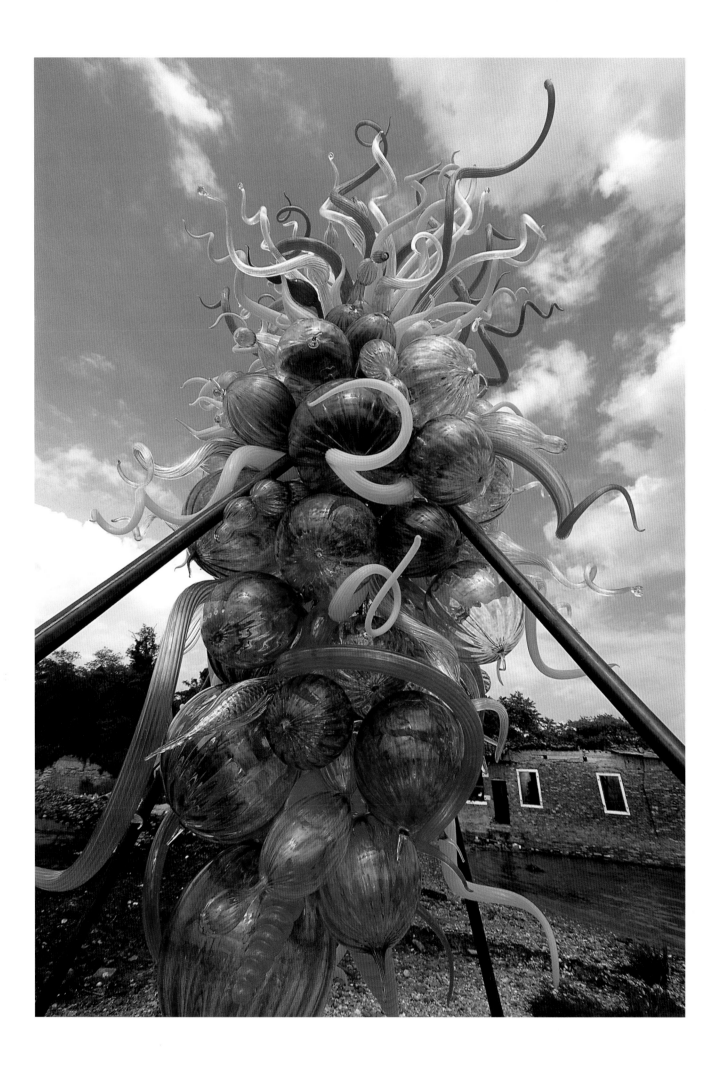

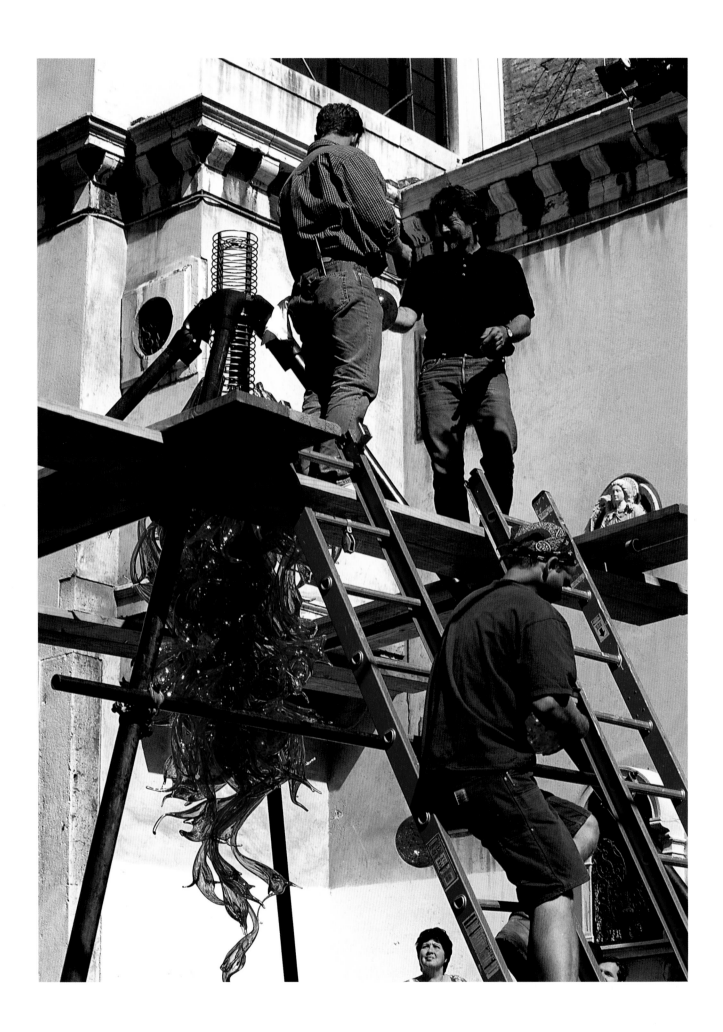

CHRONOLOGY

1941 Born September 20, Tacoma, Washington, to Viola and George Chihuly.

1956 Older brother, George, killed in Naval aviation practice flight

1957 Father dies

1959 Enrolls in University of Puget Sound, Tacoma

1960 Transfers to University of Washington, Seattle, in interior design

1961-62 Melts and fuses glass in his basement studio in south Seattle • Becomes rush chairman of Delta Kappa Epsilon fraternity

1962-63 Travels to Europe and Near East • In Israel works on a kibbutz

1963 Re-enters University of Washington, studying interior design and architecture under Hope Foote and Warren Hill • In weaving classes with Doris Brockway begins incorporating glass into tapestries

1964 Returns to Europe, visiting Leningrad and making first trip of many to Ireland • Receives Seattle Weavers Guild Award

1965 Meets textile designer Jack Lenor Larsen • Awarded highest honors from the American Institute of Interior Designers (now the American Society of Interior Designers) • Receives Bachelor of Arts degree in interior design, University of Washington • Works as designer for John Graham Architects, Seattle • Experimenting on his own, blows glass for the first time • Encouraged by Russell Day

1966 Works as commercial fisherman in Alaska to earn money for graduate studies in glass • On a full scholarship, enters University of Wisconsin, Madison, to study glassblowing with Harvey Littleton

1967 Receives Master of Science degree from University of Wisconsin • Enrolls in Master of Fine Arts program at Rhode Island School of Design (RISD), Providence • Teaches glass courses and works on large-scale environmental sculptures incorporating neon, plastic, and other materials • Meets Italo Scanga

1968 Receives Master of Fine Arts degree from RISD • Teaches at Haystack Mountain School of Crafts in Maine for the first of four summers • Awarded Tiffany Foundation grant for work in glass and Fulbright Fellowship to study glass in Venice • The first American glassblower to work on the island of Murano, begins at Venini factory

1969 Continues at Venini • Visits Erwin Eisch in Germany and Jaroslava Brychtova and Stanislav Libensky in Czechoslovakia • Returns to RISD to establish glass department • Included in "Objects USA," a collection compiled by Paul J. Smith and Lee Nordness for Johnson Wax Company that toured the U.S. and Europe, premiering at the National Collection of Fine Arts (now the National Collection of American Art), Smithsonian Institution, Washington, DC

1970 Meets James Carpenter at RISD and begins four-year collaboration • Included in "Toledo Glass National III," a circulating exhibition organized by the Toledo Museum of Art, Ohio

1971 Has exhibition with James Carpenter at the Museum of Contemporary Crafts (now the American Craft Museum), New York • With a grant from the Union of Independent Colleges of Art, starts the Pilchuck Glass School north of Seattle on property donated by arts patrons John Hauberg and Anne Gould Hauberg

1972-73 Returns to Venice and blows glass with James Carpenter at Venini to prepare for "Glas Heute" exhibition at the Museum Bellerive, Zurich • Works on architectural glass projects with Carpenter • Included in traveling show, "American Glass Now," organized by the Toledo Museum of Art and the Museum of Contemporary Crafts

1974 Tours European glass centers with Thomas Buechner, director, Corning Museum of Glass • Experiments on new "glass drawing pick-up techniques" at Pilchuck • Builds glass studio at Institute of American Indian Art, Santa Fe

1975 Receives National Endowment for the Arts grant • Develops *Navajo Blanket Cylinder* series • Helps start glass program at University of Utah's Snowbird Art School outside Salt Lake City • Solo exhibition of *Blanket Cylinders* at Utah Museum of Fine Arts, Salt Lake City, and Institute of American Indian Art, Santa Fe

1976 Collaborates with Seaver Leslie on *Irish* and *Ulysses Cylinders*, with Flora Mace fabricating glass drawings • Travels with Leslie to Great Britain on lecture tour; loses sight in left eye in automobile accident • Henry Geldzahler, curator of contemporary art at the Metropolitan Museum of Art, New York, purchases three *Navajo Blanket Cylinders* for the permanent collection • Western Association of Art Museums circulates solo exhibition • Receives an Individual Artist's Grant and, with Kate Elliott, a Master Craftsman Apprenticeship Grant from the National Endowment for the Arts

1977 Becomes head of RISD sculpture department • Begins *Pilchuck Basket* series, inspired by Northwest Coast Indian baskets at Washington State Historical Museum, Tacoma • Exhibits at Seattle Art Museum with Italo Scanga and James Carpenter in show curated by Charles Cowles

1978 Exhibition "Baskets and Cylinders: Recent Work by Dale Chihuly" shown at the Renwick Gallery, Smithsonian Institution, Washington, DC • Meets William Morris, beginning an eight-year working relationship

1979 Works in Baden, Austria, with Benjamin Moore, William Morris, and Michael Scheiner • Has solo shows at Lobmeyr, Vienna, and Museu de Arte, São Paulo, Brazil • Relinquishes gaffer position when shoulder becomes dislocated • Included in traveling exhibition, "New Glass," organized by the Corning Museum of Glass

1980 Becomes artist-in-residence at RISD after resigning as head of glass department • Begins *Seaform* series • Solo exhibition at Haaretz Museum, Tel Aviv, Israel • Executes large-scale, acid-etched, handblown stained-glass windows for Shaare Emeth Synagogue in St. Louis, with the assistance of Eric Hopkins and Eve Kaplan

1981 Begins *Macchia* series • Works in Austria with Benjamin Moore, Richard Royal, and Jeff Held • Has solo exhibitions at Lobmeyr, Vienna, and Rosenthal, Berlin • Returns to work at RISD • Travels to Scotland with William Morris and continues on to Orkney Islands • Spends summer and fall at Pilchuck

1982 "Chihuly Glass" exhibition focusing on *Seaforms* opens at Tacoma Art Museum and travels through 1984 to five U.S. museums • Works at various glassblowing facilities throughout the country

1983 Sells "Boathouse" studio in Rhode Island • Moves to Seattle

1984 Honored by RISD as President's Fellow • Receives Visual Artist's Award from American Council for the Arts and first of three Washington State Governor's Art Awards • "Chihuly: A Decade of Glass" opens at the Bellevue Art Museum, Washington, and travels to 13 museums in the United States and Canada through 1987

1985 Commissioned to make large-scale architectural installations, including one at the Seattle Aquarium as King County Arts Commission's Honors Awards Artist • Experiments with *Flower Forms* • Renovates Buffalo Shoe Building as studio in Seattle

1986 Named Fellow of the American Craft Council • Receives honorary doctorates from the University of Puget Sound and RISD and Governor's Art Award from Rhode Island • Begins *Soft Cylinder* series • Begins *Persian* series with gaffer Martin Blank • Builds his first glassblowing studio at the Van de Kamp Building in Seattle • Survey exhibition, "Dale Chihuly: Objets de Verre," organized by the Musée des Arts Décoratifs, Palais du Louvre, Paris, opens and travels in Europe and the Middle East through 1991

1987 Completes *Rainbow Frieze* installation at Rockefeller Center, New York • Honored as University of Washington Alumni Legend • Retrospective "Chihuly Collection" installed permanently at the Tacoma Art Museum

1988 Begins *Venetian* series with Lino Tagliapietra, inspired by a private collection of Venetian Art Deco vases • Receives honorary doctorate from California College of Arts and Crafts, Oakland

1989 Continues to work with Lino Tagliapietra, Richard Royal, and Benjamin Moore as gaffers on *Venetian* series • Blows glass in Niijima, Japan, and at RISD and California College of Arts and Crafts • Solo exhibition at Bienal de São Paulo travels to Santiago, Chile • At Pilchuck works with Italian Pino Signoretto, experimenting with additions of *putti* to *Venetians* • Begins to experiment with Lino Tagliapietra adding *Flower Forms* to *Venetians* for the *Ikebana* series

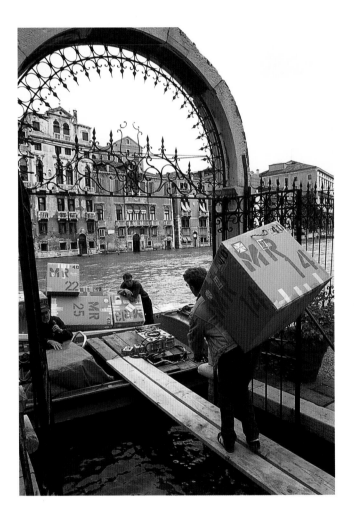
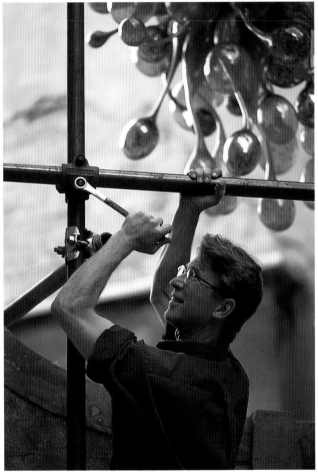

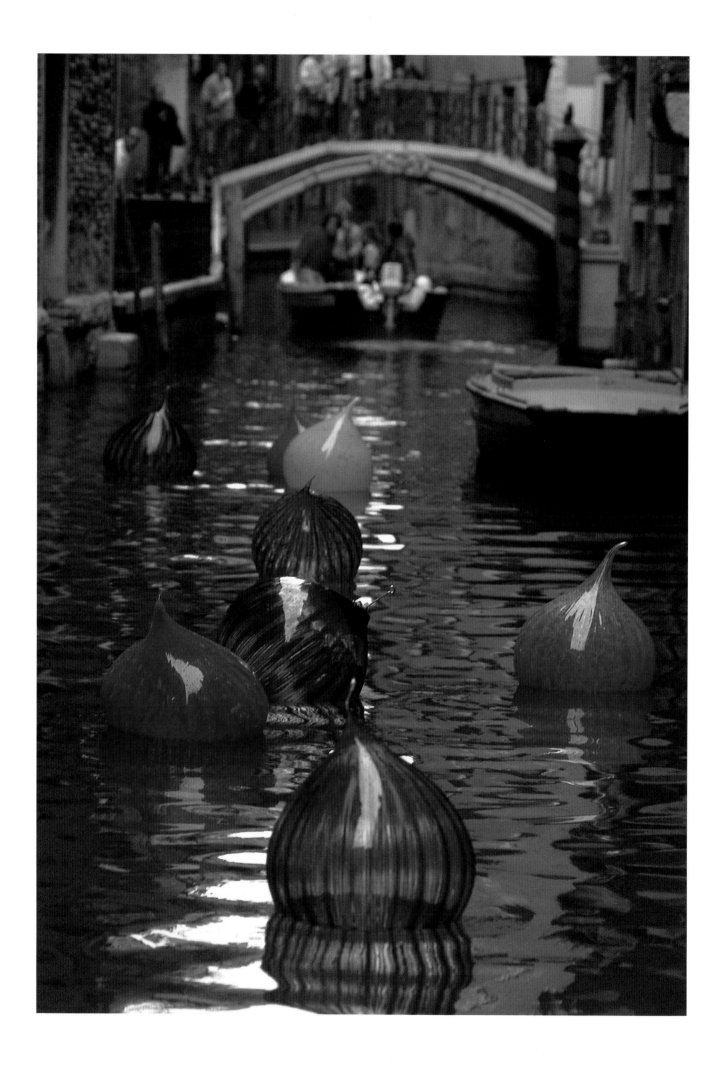

1990 Survey exhibition, "Dale Chihuly: Japan 1990," presented by Azabu Museum of Arts and Crafts, Tokyo • Renovates Seattle Pocock racing shell factory on Lake Union into new "Boathouse," incorporating glassblowing shop, studio, and residence • Develops *Venetians* further with Lino Tagliapietra and Pino Signoretto in Seattle

1991 Exhibition "Chihuly: Venetians," originating at the Umeléckopr ůmyslové muzeum, Prague, travels in Europe • Completes major private and public architectural installations, including a tea room at the Yasui Konpira-gu Shinto Shrine in Kyoto, Japan, and a wall piece at GTE Telephone Operations Headquarters in Irving, Texas • Participates in "Masterpieces" workshop at Pilchuck with Lino Tagliapietra, Richard Marquis, and William Warmus • Begins *Niijima Float* series, working with gaffer Richard Royal

1992 Exhibits *Niijima Floats* at the American Craft Museum • Exhibition of *Venetians* shown at major museums in Sweden, Germany, The Netherlands, and Belgium • Creates architectural installations for traveling exhibition organized by the Seattle Art Museum, "Dale Chihuly: Installations 1964-1992"; recreates *20,000 pounds of Ice and Neon* (1971) temporary installation • *Chandelier* series begins with the *SAM Chandelier* • Solo exhibitions featuring large-scale installations held at the Contemporary Arts Center, Cincinnati; the Honolulu Academy of Arts, Hawaii; and the Taipei Fine Arts Museum, Taiwan • Exhibits *Niijima Floats* at the Marco Museum, Monterrey, Mexico • Commissioned for large-scale architectural installations by Little Caesars World Headquarters, Detroit, and Corning Glass in Corning, New York • Designs stage sets for 1993 Seattle Opera production of Claude Debussy's *Pelléas et Mélisande* • Receives first National Living Treasure Award given in the United States

1993 "Chihuly: Form from Fire" begins tour in U.S. at the Lowe Art Museum, Miami • "Chihuly in Australia: Glass and Works on Paper," opens at the Powerhouse Museum, Sydney, Australia, and travels to the National Gallery of Victoria, Melbourne • "Chihuly Installations: 1964-1992" tours the U.S. • Seattle Opera premieres stage sets for *Pelléas et Mélisande* • Mayor Norm Rice declares March 13 "Dale Chihuly Day" in Seattle • Creates his first suite of etchings, inspired by *Pelléas et Mélisande* • "alla Macchia" opens at the Art Museum of Southeast Texas, Beaumont, and

tours U.S. • Named the 1993 Alumnus Summa Laude Dignatus by the Alumni Association, University of Washington, Seattle • *Macchia* used as backdrop for President Clinton's speech at the Asian Pacific Economic Conference in Seattle

1994 "alla Macchia" travels to Laguna Gloria Art Museum, Austin, Texas • "Chihuly in Australia: Glass and Works on Paper" travels to Scitech Discovery Centre, Perth, Australia • "Chihuly in New Zealand" opens at the Dowse Art Museum, Aotearoa, New Zealand. • "Chihuly Baskets," opens at the North Central Washington Museum, Wenatchee • "Dale Chihuly Center for Glass" opens Union Station in Tacoma, Washington • "Chihuly: Form from Fire" travels to Samuel P. Harn Museum of Art, University of Florida, Gainsville • "Chihuly and the Opera Sets" featured in Gala Celebration at the Renwick Gallery, Smithsonian Institution, Washington, DC • Receives American Academy of Achievement Golden Plate Award

1995 *Cerulean Blue Macchia with Chartreuse Lip Wrap* given to the White House Collection of American Crafts • Chihuly Over Venice project begins with blows and installations in Nuutajärvi, Finland, and Waterford, Ireland • "Chihuly: Seaforms" published • Columbus Visitors Center *Chandelier* installed in building designed by Kevin Roche • Exhibitions in Korea, Japan, and Taiwan • Installs Microsoft *Chandelier*, Microsoft, Redmond, and *Hart Window*, Dallas Museum of Art, as well as numerous other corporate and private commissions • Installs "Chihuly e Spoleto in Italy" • Begins four-year project to build the International Museum of Modern Glass in Tacoma, Washington, including the Chihuly Bridge over Thea Foss Waterway

1996 "Seaforms" traveling exhibition begins at the Corcoran Gallery of Art, Washington, DC • Installs *Persian Window* at the Singapore Art Museum, Singapore • Governors Ball Installation for the Academy of Motion Pictures, Hollywood, California • Installs *Singapore Sunrise* and *Singapore Spring* at the Ritz-Carlton Millenia Hotel, Singapore • Meany Hall Installation completed at University of Washington, Seattle • Crystal Gardens installations at Jack Lenor Larsen's LongHouse shows during summer • Chihuly Over Venice continues in Monterrey, Mexico, and culminates in September in Venice, Italy

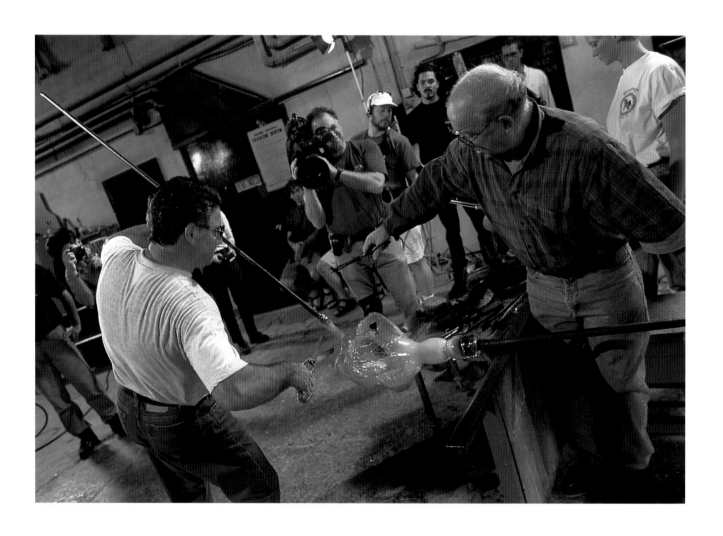

SELECTED MUSEUM COLLECTIONS

United States

Albright-Knox Art Gallery, Buffalo, New York
American Craft Museum, New York, New York
American Glass Museum, Millville, New Jersey
Amon Carter Museum, Fort Worth, Texas
Arkansas Arts Center, Little Rock, Arkansas
Art Museum of Arizona State, Tempe, Arizona
Baltimore Museum of Art, Baltimore, Maryland
Bellevue Art Museum, Bellevue, Washington
Birmingham Museum of Art, Birmingham, Alabama
Boca Raton Museum, Boca Raton, Florida
Boston Museum of Fine Arts, Boston, Massachusetts
Carnegie Museum of Art, Pittsburgh, Pennsylvania
Chrysler Museum of Fine Art, Norfolk, Virginia
Cleveland Art Museum, Cleveland, Ohio
Columbus Museum of Art, Columbus, Ohio
Contemporary Arts Center of Hawaii, Honolulu, Hawaii
Cooper-Hewitt Museum, Smithsonian Institution
 National Museum of Design, New York
Corning Museum of Glass, Corning, New York
Crocker Art Museum, Sacramento, California
Currier Gallery of Art, Manchester, New Hampshire
Dallas Museum of Art, Dallas, Texas
De Cordova Museum and Sculpture Park, Lincoln,
 Massachusetts
Denver Art Museum, Denver, Colorado
Elvehjem Museum of Art, University of Wisconsin,
 Madison, Wisconsin
Everson Museum of Art, Syracuse, New York
Fine Arts Museum of the South, Mobile, Alabama
Grand Rapids Museum, Grand Rapids, Michigan
High Museum of Art, Atlanta, Georgia
Honolulu Academy of Art, Honolulu, Hawaii
Hunter Museum of Art, Chattanooga, Tennessee
Indianapolis Museum of Art, Indianapolis, Indiana
J.B. Speed Art Museum, Louisville, Kentucky
Jesse Besser Museum, Alpena, Michigan
Jundt Art Museum, Gonzaga University, Spokane,
 Washington
Krannert Art Museum, University of Illinois, Champaign,
 Illinois
Leigh Yawkey Woodson Art Museum, Wausau, Wisconsin
Los Angeles County Museum of Art, Los Angeles,
 California
Lowe Art Museum, Coral Gables, Florida
Lyman Allyn Art Museum, New London, Connecticut
Madison Art Center, Madison, Wisconsin
Metropolitan Museum of Art, New York City
Milwaukee Art Museum, Milwaukee, Wisconsin
Morris Museum, Morristown, New Jersey
Museum of Art, Fort Lauderdale, Florida
Museum of Art, Rhode Island School of Design,
 Providence, Rhode Island
Museum of Art and Archaeology, Columbia, Missouri

Museum of Contemporary Art, Chicago, Illinois
Museum of Contemporary Art, La Jolla, California
Museum of Fine Arts, Boston, Massachusetts
Museum of Modern Art, New York, New York
Muskegon Museum of Art, Muskegon, Michigan
National Museum of American History, Smithsonian
 Institution, Washington, DC
New Orleans Museum of Art, New Orleans, Louisiana
Newport Harbor Art Museum, Newport Beach, California
Palm Beach Community Collage Art Museum, Lake
 Worth, Florida
Parrish Museum of Art, Southampton, New York
Philadelphia Museum of Art, Philadelphia, Pennsylvania
Phoenix Art Museum, Phoenix, Arizona
Portland Art Museum, Portland, Oregon
Princeton University of Art Museum, Princeton, New
 Jersey
Renwick Gallery, National Museum of Modern Art,
 Smithsonian Institution, Washington DC
Saint Louis Art Museum, Saint Louis, Missouri
San Francisco Museum of Modern Art, San Francisco,
 California
San Jose Museum of Art, San Jose, California
Seattle Art Museum, Seattle, Washington
Smith College Museum of Art, Northampton,
 Massachusetts
Spencer Museum of Art, University of Kansas, Lawrence,
 Kansas
Tacoma Art Museum, Tacoma, Washington
The Detroit Institute of Arts, Detroit, Michigan
Toledo Museum of Art, Toledo, Ohio
University Art Museum, University of California, Berkeley,
 California
University of Michigan, Dearborn, Michigan
Utah Museum of Fine Arts, Salt Lake City, Utah
Wadsworth Atheneum, Hartford, Connecticut
Whatcom Museum of History and Art, Bellingham,
 Washington
White House Craft Collection, Washington, DC
Whitney Museum of American Art, New York, New York
Yale University Art Gallery, New Haven, Connecticut

International

Art Gallery of Greater Victoria, British Columbia, Canada
Art Gallery of Western Australia, Perth, Australia
Auckland Museum, Auckland, New Zealand
Australian National Gallery, Canberra, Australia
Azabu Arts and Crafts Museum of Tokyo, Tokyo, Japan
Dowse Art Museum, Aotearoa, New Zealand
Galerie d'Art Contemporain, Nice, France
Glasmuseum Ebeltoft, Ebeltoft, Denmark
Glasmuseum Frauenau, Frauenau, Germany
Glasmuseum Wertheim, Wertheim, Germany
Haaretz Museum, Tel Aviv, Israel
Hawke's Bay Exhibition Centre, Napier, New Zealand
Hokkaido Museum of Modern Art, Hokkaido, Japan

Israel Museum, Jerusalem, Israel
Japan Institute of Arts and Crafts, Tokyo, Japan
Kestner Museum, Hannover, Germany
Kunstammlungen der Veste Coburg, Coburg, Germany
Kunstindustrimuseum Kopenhagen, Copenhagen,
 Denmark
Kunstmuseum, Dusseldorf, Germany
Kyoto Museum, Kyoto, Japan
Lobmeyr Museum, Vienna, Austria
Manawatu Museum, Palmerston North, New Zealand
Musee d'art Moderne et d'art Contemporain, Nice, France
Musee des Arts Decoratifs, Palais du Louvre, France
Musee des Arts Decoratifs, Lausanne, Switzerland
Musee des Beaux Arts et de la Ceramique, Rouen, France
Museo del Vidrio, Monterrey, Mexico
Museum Bellerive, Zurich, Switzerland
Museum Boymans-Van Beuningen, Rotterdam, Holland
Museum fur Kunst und Gewerbe, Hamburg, Germany
Museum fur Kunsthandwerk, Frankfurt, Germany
Museum of Moderne Art, Nice, France
Muzeum Mesta Brna, Brno, Czech Republic
Muzeum Skla A Bizuterie, Jablonec nad Nisou,
 Czech Republic
National Gallery of Victoria, Melbourne, Australia
National Museum, Stockholm, Sweden
National Museum of Modern Art, Kyoto, Japan
Notojima Glass Museum, Ishikawa, Japan
Otago Museum, Dunedin, New Zealand
Powerhouse Museum, Sydney, Australia
Provincial Musee Sterckshof, Antwerpen, Belgium
Queensland Art Gallery, Brisbane, Australia
Robert McDougall Gallery, Christchurch, New Zealand
Royal Ontario Museum, Toronto, Ontario, Canada
Scitech Discovery Centre, Perth, Australia
Shimonoseki City Art Museum, Shimonoseki, Japan
Singapore Art Museum, Singapore
Suomenlasimuseo, Riihimaki, Finland
Taipei Museum of Fine Arts, Taiwan
Umeleckoprumsylove Museum, Prague, Czech Republic
Victoria and Albert Museum, London, England
Waikato Museum, Hamilton, New Zealand
Walker Hill Art Center, Seoul, Korea
Yokohama Museum, Yokahama, Japan

PUBLIC INSTALLATIONS

United States
Birmingham Art Museum, Birmingham, Alabama
Chancellor Park, San Diego, California
Corning World Headquarters, Corning, New York, with
 Kevin Roche
Dallas Museum of Art, Dallas, Texas
Denver Banking Center, Denver, Colorado
Fleet National Bank, Providence, Rhode Island
Frank Russell Building, Tacoma, Washington
Gonzaga University, Spokane, Washington
GTE Telephone Operations Headquarters, Irving, Texas
Hillhaven Corporation, Tacoma, Washington
Japan-America Society, Seattle, Washington
King and Spalding, Washington, DC
Little Caesars World Headquarters, Detroit, Michigan
Liz Clairborne Headquarters, New York, New York
Madison Stouffer Hotel, Seattle, Washington
MCI Communications World Headquarters, Washington,
 D.C.
Microsoft Corporate Headquarters, Redmond, Washington
Pacific Lutheran University, Tacoma, Washington, with
 Zimmer Gunsul Frasca
Rainbow Pavilion, Rockefeller Center, New York, New York
Robins, Caplan Miller & Ciresi, Minneapolis, Minnesota
Seattle Aquarium, Seattle, Washington
Seattle Sheraton, Seattle, Washington
Shaare Emeth Synagogue, St. Louis, Missouri
Sheraton Hotel, Tacoma, Washington
Tacoma Financial Center, Tacoma, Washington
The Ohio State University, Columbus, Ohio
Tropicana Headquarters, Branderton, Florida
U.S. Bank Center, Seattle, Washington
Union Station, Tacoma, Washington – temporary
United States Border Station, Blaine, Washington
Visitor's Center, Columbus, Indiana, with Kevin Roche
Washington Convention Center, Seattle, Washington

International
Amsterdam International Airport, Amsterdam, Holland,
 with Vignelli Associates
Crafts Council, Sydney, Australia
Hoffman Laroche Headquarters, Basel, Switzerland
Hyatt Hotel, Adelaide, Australia
Iittala Glassworks, Nuutajärvi, Finland
Ritz-Carlton Millenia, Singapore, with Kevin Roche
S.S.Oceanic Grace, Tokyo, Japan
Singapore Art Museum, Singapore
Yasuri Konpira-gu Shinto Shrine, Kyoto, Japan

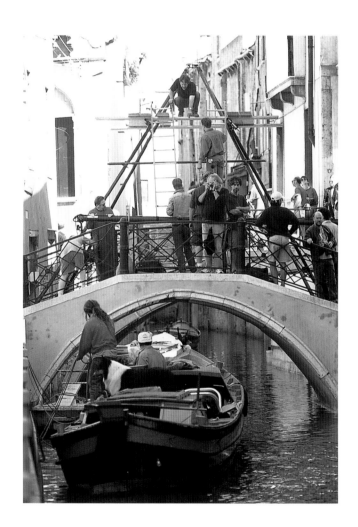

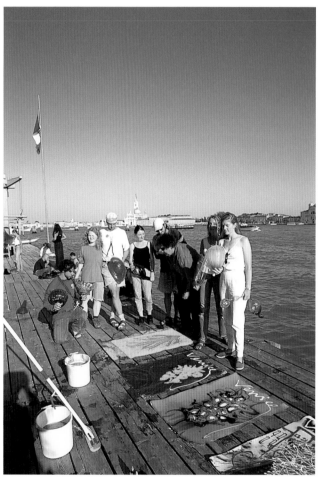

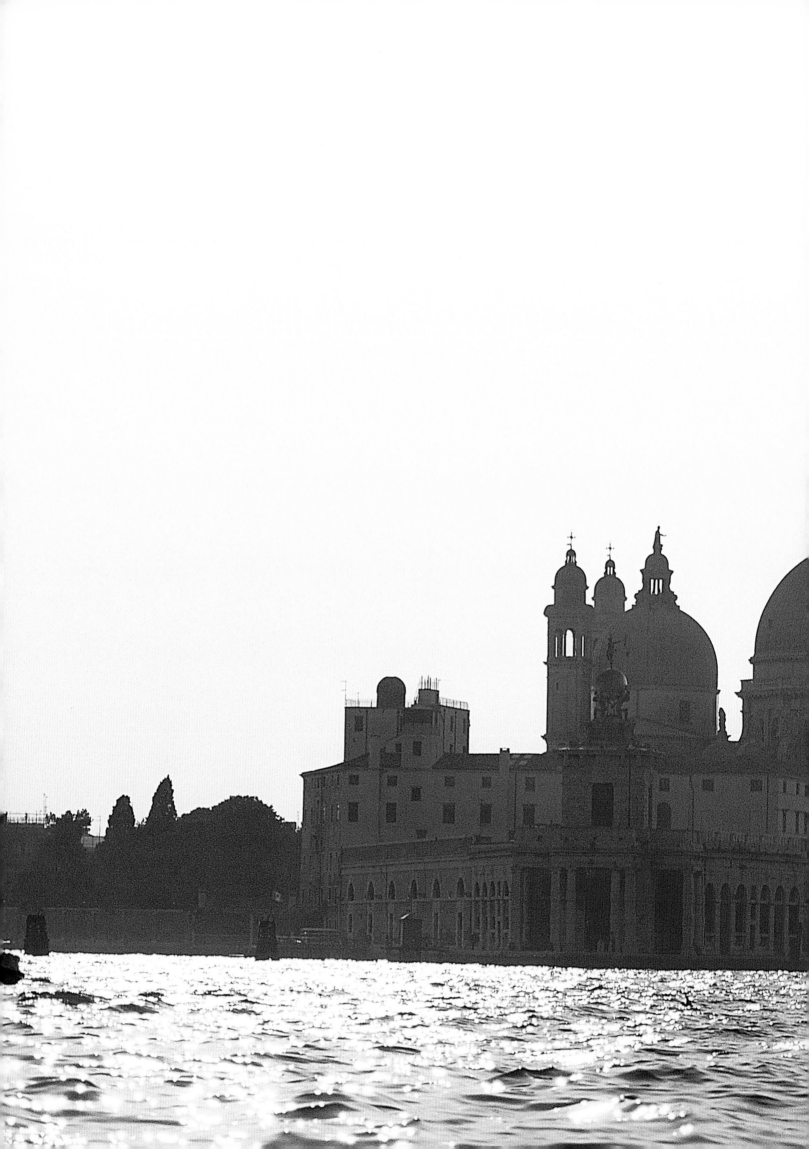

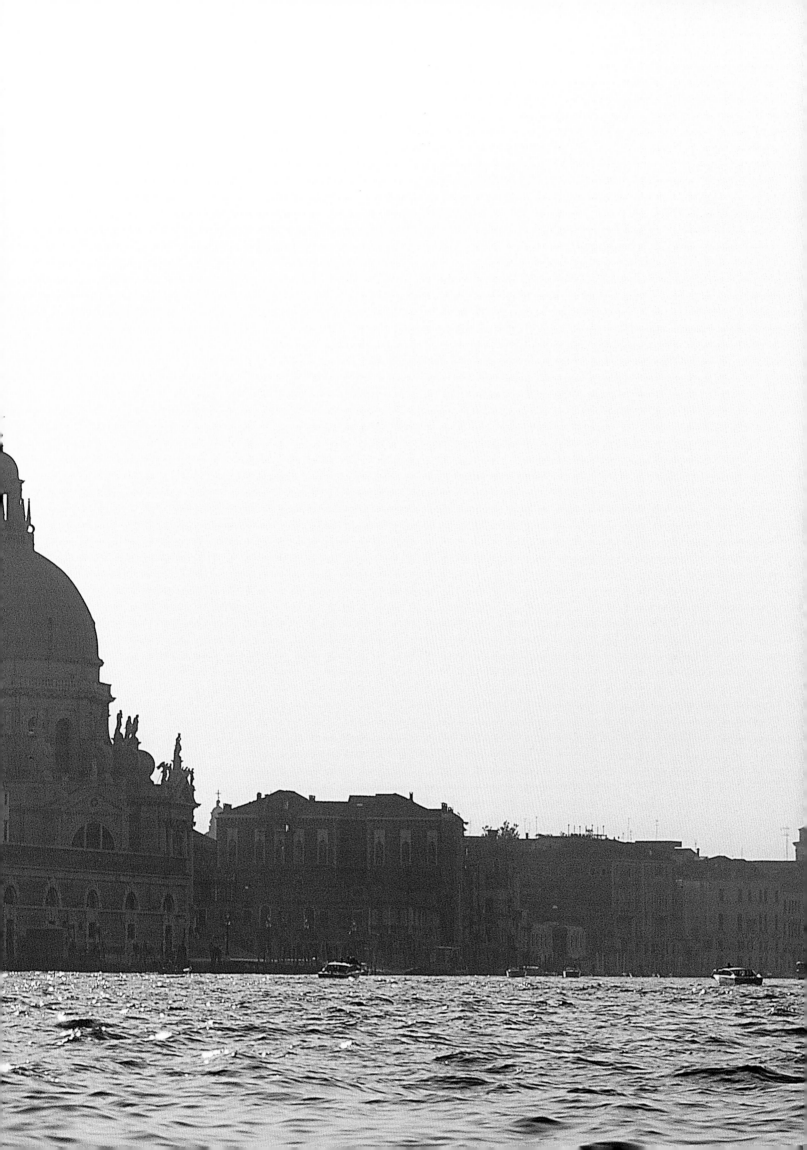

The artists and artisans who blew and built the Chandeliers over Venice

Finland ● Ireland ● Mexico ● Italy ● U.S.A. ●

Name	Finland	Ireland	Mexico	Italy	U.S.A.
Kari Alakoski	●				
Parks Anderson	●	●	●	●	●
Shael Anderson				●	
Francesco Anfodillo				●	
Leonardo Argil		●			
Paul Bergin		●			
Anna Bergman	●				
Kai-Uwe Bergmann			●	●	
Tony Biancaniello			●		
Martin Blank	●	●	●		
Ryan Blythe			●		
Michael Bray	●	●	●	●	
Mick Calnan		●		●	
J.P. Canlis			●		
Adalberto Cantú		●			
Shaun Chappell	●	●	●	●	
Mick Connolly		●			
John Coushlan		●			
Patricia Davidson		●	●		
Joe DeCamp	●	●	●	●	
Paul DeSomma			●	●	
John deWit		●	●		
Rachel Durand		●	●		
Michael Fagan		●			
Nicola Ferrari				●	
Paul Fisher	●	●			
Enda Flannigan		●			
Jackie Flynn					●
Michael Flynn					●
Tony Foley					●
Bruce Greek	●	●			●
Amber Hauch				●	
Alejandro Hernández			●		
Jose Hernández			●		
Noelle Higgins	●	●	●		●
Anne Hynes			●		
Maria Iitola	●				
Alma Jantunen	●				
Bennett Jordan					●
Ossi Kaarineva	●				
Kaarina Karlsten	●				
Jakes Keane					●
Maurice Kelly					●
Tom Kiely					●
John Kiley	●	●	●	●	●
John Landon				●	●
Helena Lavery					●
Tom Lind	●	●	●		●
Clay Logan					●
Dan Lowman					●
Gustavo Lugo					●
Peter Maguire					●
Sauli Mäkinen	●				
Bonifacio Martínez					●

Camilo Martínez ●	Jose S. Rodríguez ●
Joe McEvoy ●	Dierdre Rogers ●
Vinney McEvoy ●	Joseph Rossano ● ● ● ●
John McGrath ●	Tom Roue ●
Rick McNett ● ● ●	Richard Royal ● ●
Robbie Miller ●	Kyösti Ryyppö ●
Joan Monetta ● ●	Reijo Salonen ●
James Mongrain ● ● ●	Dionisio Sánchez ●
Blas Montelongo ●	Pietro Sartoret ●
Ray Moran ●	Henry Scheinin ●
Tom Morrissey ●	Leon Shabott ●
Timo Niekka ●	Pino Signoretto ●
John O'Mahoney ●	Holly Simmons ●
Noel O'Sullivan ●	Gail Sinnott ●
DJ Palin ● ●	Jari-Matti Solin ●
Bob Park ●	Daniel Spitzer ● ● ● ●
Charles Parriott ●	Mark Stevens ●
Eric Pauli ●	Paula Stokes ● ●
José A. Pequeño ●	Taisto Sundell ●
John "Shamie" Power ●	Unto Suominen ●
Juan M. Puente ●	Lino Tagliapietra ●
Heikki Punkari ●	Mario Tagliapietra ●
Johannes Rantasalo ●	Markku Uskelin ●
Ashley Rowley ●	Marko Uskelin ●
César N. Rendón ●	Riika Velling
Eddie Roche ●	Jim Wheelan ●
Alejandro Rodríguez ●	Davide Zanella ●